BRIGHTON & HOVE IN 50 BUILDINGS

G000255198

KEVIN NEWMAN

AMBERLEY

For Seth and Eddie

First published 2016

Amberley Publishing, The Hill, Stroud
Gloucestershire GL5 4EP

www.amberley-books.com

British Library Cataloguing in Publication Data.
A catalogue record for this book is available from the British Library.

ISBN 978 1 4456 5514 7 (print)
ISBN 978 1 4456 5515 4 (ebook)

Typesetting and Origination by Amberley Publishing.
Printed in Great Britain.

Contents

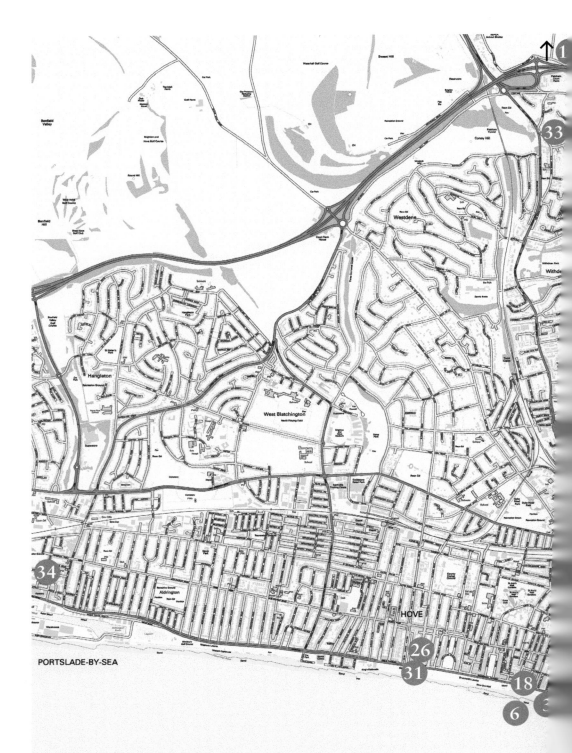

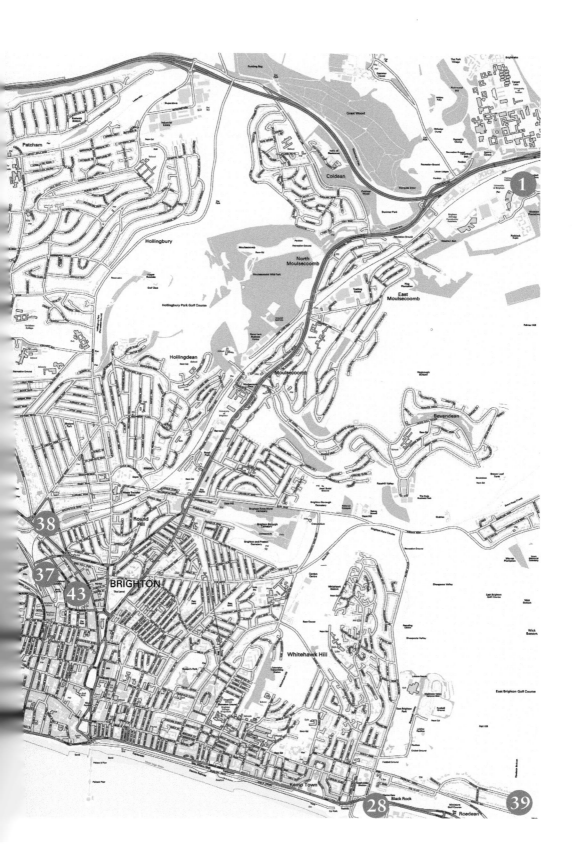

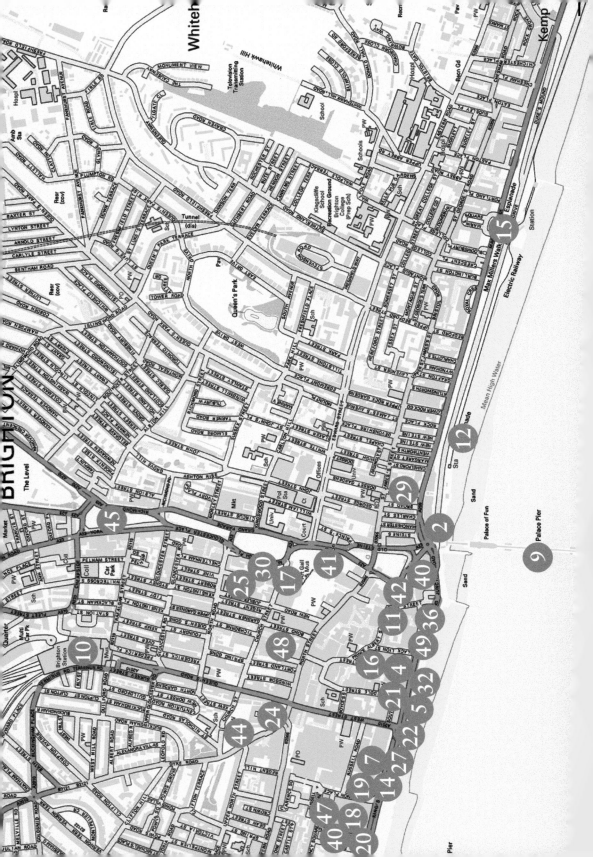

Introduction

Brighton and Hove is a city defined by its buildings. Whether you are an architect, historian or just a visitor to the 'Queen of watering places' as Horace Smith the poet remarked, you cannot help but be moved by the wonderful of range of exciting, dynamic and eccentric buildings this seaside city is blessed with.

Brighton was the first development of its kind, where a small fishing town became not just the health resort of the rich, royal and famous, but also the summer residence of a head of state and the accompanying numbers of courtiers, aristocracy and well-to-do who followed. It was the first example of a development of numerous squares, terraces and crescents on a par with Bath but actually facing the sea for the first time. The main crescent in Kemp Town, Lewes Crescent, is actually bigger than Bath's grandest one. Brighton developed from a small, enclosed fisherman's town to a large development including Regency and nineteenth-century grand buildings – the first seaside resort for the wealthy. Accompanying the wealthy came the other classes needed to support them, and eventually the railways and other industries needed later on to bring the masses to the town and keep them in employment. Brighton reflects all of this today and its buildings show the changes over time in the role of this ever-reinventing location, but also its different residents of all classes.

No other south coast city has as many listed buildings as Brighton and Hove (1,218). Pevsner and Nairn, the country's top architectural historians, said back in 1965 that the rest of '[West] Sussex has always been secondary to the glories of Brighton'. They went on to describe the rest of the Sussex coast as just a 'bleak windswept collection of fishermen's cottages'. That may have been a bit of an exaggeration, but Brighton has a rich and varied range of architecture built for the upper classes, unequalled in any other seaside resort. As much as I therefore appreciate Brighton as an architectural gem, in this book however, I want to focus on attempting to tell the tale of the city (as it has been since 2000) before and after its sumptuous Regency and other terraces. Therefore, I have avoided telling the tale of whole developments such as Kemp Town, Brunswick or even squares and crescents such as Regency Square. These have been covered well by authors such as the great Anthony Dale. By 'Buildings' in the title I refer to *individual* buildings therefore. I have also taken the term 'building' to mean a construction, so interesting builds such the Marina are included. I have also avoided pubs, except for the wonderful Cricketers and King and Queen, as they have been covered by my colleague at Amberley, David Muggleton, in our other publication *Brighton Pubs*.

In terms of chronology, I have tried to dip into the story of Brighton and Hove not only before its fashionable era when the aristocracy came, but after as well, and hopefully this is in reflected in that the buildings mentioned are of all the people that have made this unique city. Buildings were built by people and this is a history of those people too. I have mentioned the most famous buildings, such as the piers and the Pavilion, but have also

tried to inspire even the oldest Brightonian to find buildings they have never noticed, or at least to look at them again with a fresh perspective. I hope in this book I have included everyone's favourites, but also the buildings that are unique, unusual, quirky and have a good tale to tell. I have tried to cover what has happened in them to make them of interest, not just a description of architectural features or of their building and development over time. If this book makes both visitors and residents get out and explore this city I love, then I will have achieved my objective. There is always more to discover about Brighton and Hove, and I hope that this will be, for many, an interesting start or next step.

The 50 Buildings

1. American Express Community Stadium (Brighton and Hove Albion Football Club)

The American Express Community Stadium of Brighton and Hove Albion Football Club is a modern expression of Brighton as a sporting city as well as a dynamic gatehouse to the city from the north-east. Based on the Lewes Road opposite Sussex University, it is an incredible building as it houses not just the dreams of local football fans but audio speakers in a number of rooms so that the manager at the time of its construction, Gus Poyet, could instruct and inspire the players wherever they were!

The 'Amex', as it's known, is not the Albion's first location, nor were the Seagulls (as Brighton and Hove Albion are known) Brighton's first football team. That honour went to Brighton United, who played at the County Ground. There was also a team comprising Brighton and Hove Rangers and Brighton United players. It was the Rangers in this amalgamated team that were to rename and form the Albion in 1901, moving to the Goldstone in 1902, which was said to be the nearest bit of flat ground to Brighton. It had been home to Hove FC until then. The Albion's height of fame was reaching the FA Cup final in 1983 and drawing 2-2 to Manchester United and their lowest point must be leaving the Goldstone Ground, their previous permanent home, when it was developed to help solve money problems in 1997. It is indeed amazing that the Albion are now doing so well in both football and financial terms when back in 1993 they had debts of over £3 million and would have to play at someone else's pitch at Gillingham, in Kent. Things got even worse when, humiliatingly, they had to play at the Withdean Stadium, somewhere that, as a one-time mortuary in the Second World War, seemed to reflect the club's looming death.

The American Express Community Stadium. (Picture courtesy of the *Argus*)

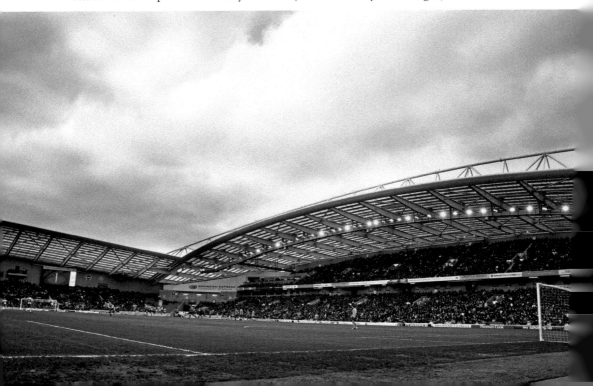

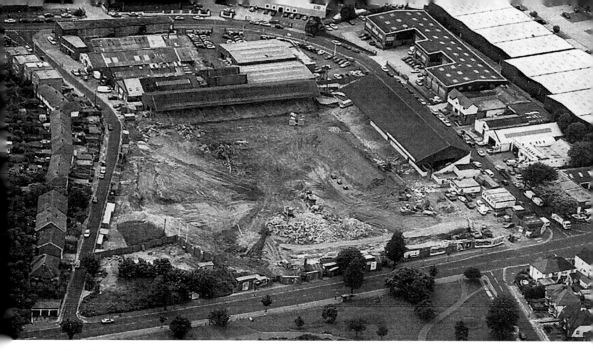

The Albion's Goldstone ground, being cleared in the 1990s for redevelopment when the Albion faced financial difficulties.

Withdean being a zoo was most apt as a number of creatures that featured in avian zoos were recommended for the club's nickname. 'Seagulls' was not always the default name. In the 1960s and 1970s, ships and dolphins appeared on the club's badge, showing links to the town's crest and also the coats-of-arms of local landlords. Said to have been invented by supporters in a West Street pub on Christmas Eve 1975 as a response to the Crystal Palace chant of 'Eagles, Eagles!', the cry 'Seagulls, Seagulls!' rapidly caught on and by 1977 the club's badge officially featured the bird. The earliest nickname was for Brighton's reserve team was the 'Lambs' as lambs were allowed to graze on the Goldstone pitch in its early days. By October 1950 the club was branded as 'Shrimps' in reference books. 'Dolphins' was among other attempted nicknames, including 'Holidaymakers', 'Seasiders' and even the abbreviated 'Brovions'. 'Mariners' was another as were 'Regents', 'Sovereigns', 'Bucks' and 'Royals'. Other birds were attempted: 'Bluebirds', 'Swifts', 'Seagulls' and 'Martlets', and then 'Southdowners', which today sounds like a Sussex-based soap opera, 'Goldstoners', 'Sparklers', 'Gems' and 'Diehards'.

The team weathered the dark years and despite a controversial road to its construction, today the Amex is not only a football stadium, but a successful music and events venue. The building hit international fame in 2015 when hosting the famous South Africa v. Japan match at the Rugby World Cup that Japan surprisingly went on to win.

2. The Aquarium/Sea Life Centre

Built on the entry gates and road to the old Chain Pier, the Sea Life Centre (as it has been since 1991) started life as the Aquarium, opening in August 1872. It is the work of Eugenius Birch, who also built the West Pier and was linked to another pier, the Chain Pier, in that it

Above: The Aquarium in its early days.

Left: The Aquarium interior. (Courtesy of Jackie Marsh-Hobbs)

COPYRIGHT.
Brighton Aquarium.—Central Hall.

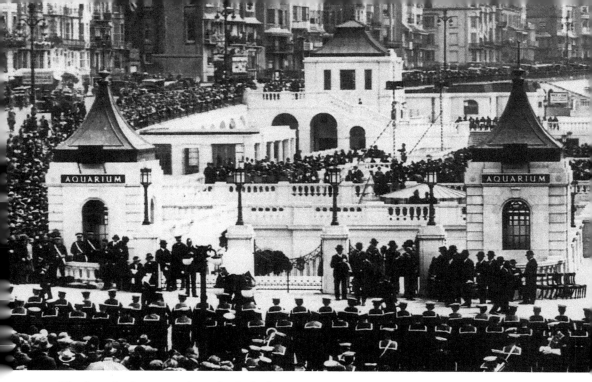

The Aquarium's revamped exterior in the late 1920s.

was built on the site of that pier's tollhouse. The world's oldest operating aquarium, it was inspired by other similar aquariums in Boulogne and elsewhere on the Continent. It was the first recreational aquarium anywhere in the country. Costing £133,000 to build (£5.5 million today), it was hailed as a fantastic piece of architecture when it opened, especially as it was constructed under the ground. The original design was meant to have towers and turrets but these weren't built as it was felt that they'd spoil sea views. This is why it is built into the cliff – the building wasn't allowed to be above the level of Marine Parade above.

The interior of the Sea Life centre is still amazing today, and takes your breath away, but the original interior when it was the Aquarium was inspired by Pompeian and Gothic influences. It was a very colourful place with statues, green marble and red Edinburgh granite. Originally it had a number of purposes, including as a lunch and concert venue, and was very much a social meeting place. It also had a reading room, cinema, conservatory and even a roller-skating rink on its roof. Its 100-foot-long tank, holding 110,000 gallons of water, was the biggest in the world at that time. Its clock tower was added along with its first entrance in 1874 and moved a few meters during this rebuild, when it became part of the entrance to the Palace Pier instead.

Early on, the Aquarium was never that profitable and its owners faced financial difficulties by the 1920s when it had fallen out of fashion. It was sold to Brighton Corporation (as the council was known then) for £30,000 – a good investment by the council, like the purchase of the Pavilion. It narrowly escaped being turned into a bus station back in 1922 and was thankfully refurbished instead at a cost of £117,000, and was reopened in 1929. It had a redesigned interior and entrance, and even includes a police station in one of the new entrance kiosks. The clock tower was moved to the Palace Pier where it still remains today. The clock tower survived damage from defensive mines exploding accidentally in 1941 and

having its workings removed for safety during the war. It has bronze statues on each of its four sides, representing the seasons.

During the Second World War, like much of Brighton, the building was requisitioned by the RAF. It became a Chinese Jazz Club and then the Florida Rooms nightclub after the war, one of the town's earliest nightclubs. It then became home to the Montagu Motor Museum before eventually becoming the Dolphinarium and Pirates Deep activity centre. By the 1990s public attitudes to keeping such intelligent large creatures in tanks had changed and it became the Sea Life Centre in 1991. Since then, it has become one of Brighton's busiest tourist and visitor attractions. It is dedicated to engaging all ages with marine life and conservation and plays a great role in educating its visitors. Its glass-bottomed boat is sometimes used for speeches and presentations, where the speakers talk to the audience while floating on water! Thanks to the stability of the glass-bottomed boat the speakers may not end up listing, but listing is what the Sea Life Centre's predecessor got – it is one of Brighton's listed buildings. It achieved this in 1971, a mere ninety-nine years after the Aquarium first opened.

3. The Bedford Hotel/Holiday Inn

Along with Kingswest Boulevard (home to Brighton's Odeon Cinema), the Holiday Inn can't be called Brighton's prettiest building, but this 1960s building on King's Road has continued to be a successful and busy home-from-home for visitors ever since its construction. It was Brighton's first large hotel for over fifty years when built by the AVP group, owned by post-war business tycoon Harold Poster.

Harold Poster is a controversial businessman from Brighton's past but his investment and his redevelopment of Brighton hotels helped make Brighton a fashionable destination for the rich and famous once again. He became the Metropole Hotel's owner from 1959, and saved the hotel by realising that the hotel's future lay as a business hotel for exhibitions and conferences, rather than relying on British holidaymakers, who were increasingly jetting away as the age of cheap foreign holidays dawned. Poster (pronounced to rhyme with Foster), came from a poor London-slum background and was a self-made man. Known as 'Mr Harold' by his staff, his company was Brighton's sixth-biggest ratepayer at its peak. He also owned the West Pier for a while, and personally financed the establishing of the Brighton Festival. His love of Brighton and the Metropole showed in the way he named many of his other new hotels he built around the country 'Metropole'. Other historic hotels like the old Bedford, however, were less favourable to him and he planned to demolish the original 1820s hotel and replace it with a modern hotel and tower block. This meant the subsequent fire and demolition that occurred after planning for the new hotel was refused, looked suspicious, especially as people died in the fire. The new hotel, designed by R. Seifert & Partners, was also named the Bedford until renamed the Hilton West Pier in the 1990s, and was sold off by the Hilton Group when it 'no longer matched their portfolio'. The new Bedford's archives are looked after today by the still-Hilton-owned Brighton Metropole, which thankfully kept its original nineteenth-century building. Lacking its own heritage, the new Bedford tried to celebrate its predecessor's literary heritage with 'Literary Lunches', but otherwise the hotel kept a low media profile in its fifty-year history.

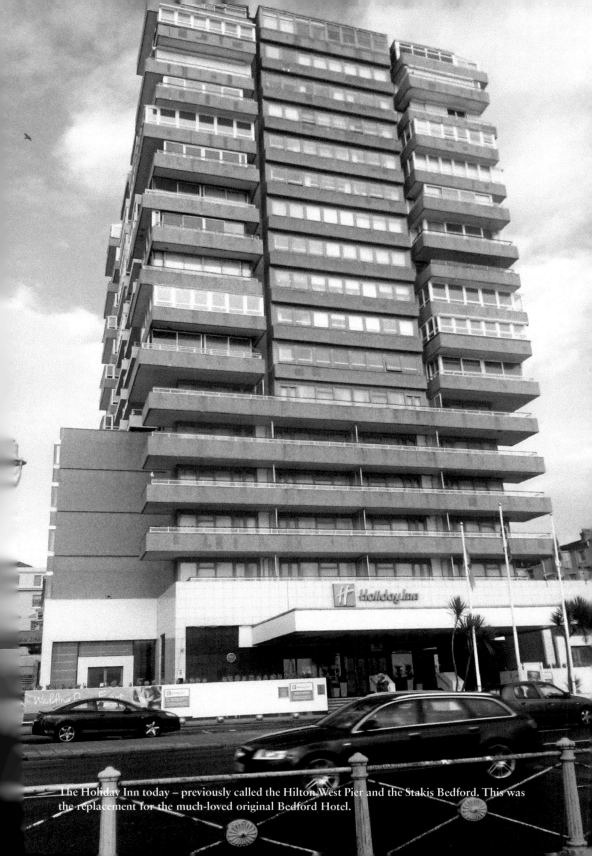

The Holiday Inn today – previously called the Hilton West Pier and the Stakis Bedford. This was the replacement for the much-loved original Bedford Hotel.

What a literary heritage the first Bedford had too! Among its visitors were Charles Dickens, who wrote *Dombey and Son* when staying there. Thankfully when the old Bedford burnt down, Dickens' letters to the hotel that were being exhibited were rescued. For many years the original Bedford was the most fashionable hotel in Brighton, and the default destination for royalty.

Returning to the present, Poster's architectural legacy is not the best bits of Brighton today, but they were of the time. He loved Brighton and although he died in 1975, we are still left with several of his new and redeveloped buildings, such as the Holiday Inn.

4. Black Lion Brewery

Deryk Carver was a Flemish immigrant to Brighton who ran the Black Lion Brewery, and the pub with this name today is a 1970s recreation of the brewery on the corner of Black Lion Passageway and Black Lion Street. It is possible that Carver's brewery was actually further south and nearer the sea but the Black Lion pub is an interesting reminder

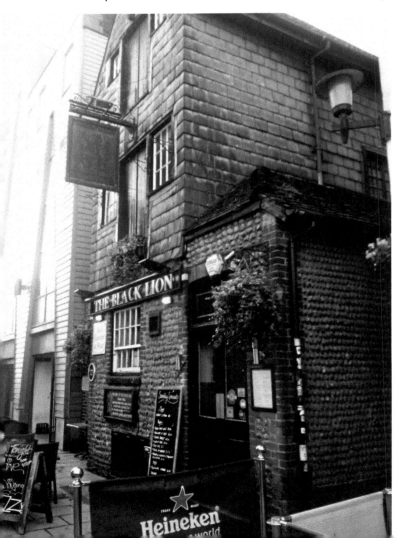

The Black Lion pub, a 1970s recreation of Deryk Carver's brewery.

of Brighton's immigrant past and of the end that Carver met. The name is apt as the Black Lion comes from the symbol of Flanders, and Carver was one of a number of immigrants from the Low Countries who brought their brewing technology with them. Prior to this exodus here by Carver and his countrymen, English beer had lacked the use of hops to create the classic British 'bitter' we serve today.

This adopted Brightonian's profession would mark the method of his death. Like many escaping persecution of Protestants in the 1500s, Carver believed in the Lutheran Church, which Henry VIII's England had also adopted during the break with Rome. Henry's daughter, Mary had been brought up before her father's changes and changed the country back to Catholicism. Earning the moniker of 'Bloody Mary', she then rounded up Protestants such as Carver who refused to surrender their beliefs. Carver was arrested for reading an English bible and on 22 July 1555 he and sixteen other Protestants were burnt in the street in Lewes opposite what is now the Town Hall. Carver was given a different death to the others – he was burnt to death in a barrel. This was meant to mock his 'lowly' profession, but without Carver and his countrymen, British people wouldn't have the beer we have today, brewed with hops the Flemish way. He and the sixteen other martyrs are the reason why seventeen burning crosses are carried through Lewes every year in its world-famous bonfire night celebrations. Ironically, one of his descendants went on to save the life of a descendant of Mary, however.

5. The Blockhouse/Battery

Being a place of play, pleasure and promenading for over two centuries, we can forget that Brighton had a military past and has been at the forefront of wars and invasions. One outcome of this was the Blockhouse, Brighton's seafront 'castle', which was built in the days of Henry VIII to help protect the coast from invasions from France. To try and prevent attacks like the French one in 1514 happening again (although there's some evidence the French tried again in 1545), Brighthelmstone, as it was known in the sixteenth century, became a defensive coastal town.

On the site of the land in front of what is now the Grand Hotel was Brighton's western armed 'Blockhouse', where cannons were placed to defend the town. There is also some evidence that Brighton had a great fortified wall along the seafront, bristling with cannon, built after the 1514 raid, which was destroyed by early eighteenth-century storms. However, by the 1770s, the Blockhouse was crumbling into the sea, despite being a fair distance from it when first built. The sea eroded the coast so quickly in that decade that some of the building even fell into the sea, the rest of it being cleared so coaches could get along what was left of the coast road. Some cannons were placed in its place in a nearby, open-air coastal battery and today the road behind that is the curved entrance road to the Grand. The town's first town clock was apparently on the Blockhouse and it also had a dungeon for the town's criminals to be locked up in. The battery which replaced the Blockhouse lasted until the 1850s and was commemorated in the 1980s by the *Argus* in a competition for readers to name the Metropole's new pub, which then opened on the site where the Salt Room is now. The pub was very aptly called the Cannon. The pub has since been renamed several times, but Cannon Place between the Grand and the Metropole is one of the few remaining reminders of the Battery, and the only other remains of that are the three smaller

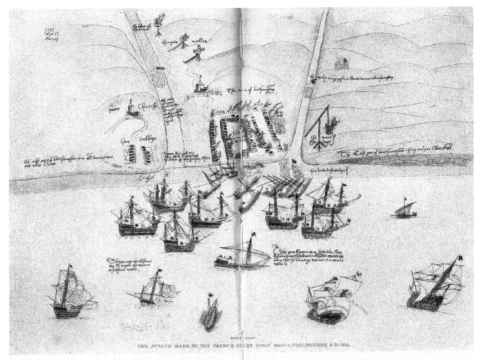

Destruction of the Tudor town by the French. Note houses on the beach; the flaming beacons and the Militia coming to the defence from Lewes and Shoreham. Reproduced from 18th cent. engraving after the drawing in the British Museum.

Above: The French attack of Brighton (1514 although it says 1545) – the first ever picture of Brighton, complete with its lower fishing town on the beach.

Below: The Tudor Blockhouse that existed on the West Cliffs.

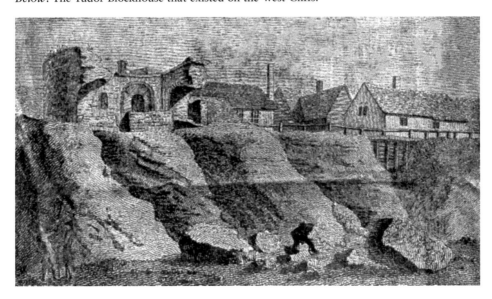

cannons which ended up as bollards at the station. Brighton also had two other batteries, one opposite Camelford Street on the East Cliffs (Marine Drive today) and another central one at the southern end of East Street. This may be why Brighton has a 'Castle Square' today and had a 'Castle Inn' when it had no castle – this may have referred to the castle-like nature of the Blockhouses.

6. Brighton's Bandstand

Built in 1884, Brighton's seafront bandstand, west of the West Pier, is not only the oldest in the country but another certain survivor as there were once thirty-six bandstands in Sussex and are now only nine. This might be because it has been described as 'all but bombproof'. It has also been voted the best in the country by bandstand enthusiast and expert Paul Rabbitts, who has written a book about bandstands. He said in an interview with the *Argus* that he liked 'the detailing of it, the design of it, the location is just incredible, the fact that there is a little coffee shop behind it, the fact you can get married in it'. He is right; what makes it unusual is that it is one of the council's licensed marriage venues. Rabbitts also liked the fact that our bandstand is unusual as it is 'right on the seafront', whereas most others are on promenades or in parks.

The bandstand, said to be the best in Britain.

7. Brighton Centre

The Brighton Centre on the King's Road cost £9 million to build by its completion in 1977, £6 million more than was estimated in the early 1970s. It was an inevitable outcome that a town that had come to depend on conferences and exhibitions would have its own, council-run purpose-built building. Brighton's need for such buildings goes back to Victorian times as the first ever Brighton conference was actually at the Royal Pavilion, just after the town had purchased it in 1853. This was when the Pavilion and Town Hall jointly hosted the 1853 meeting of the British Association for the Advancement of Science. Political parties have chosen Brighton for their conferences since before universal suffrage and so the Brighton Centre and its fellow venues are places graced not only by Prime Ministers and Cabinet members but also have been bustling centres of the political classes. As a political party with roots back to the 1600s, you would have thought that the Liberals would have come to such a liberal city for their conference earliest, but in fact the first party to hold their conference here were the Conservatives in 1875. The Liberals were even beaten by the Labour Party by forty-two years, who held their first meeting here in 1921, the Liberals only finally visiting in 1963. Despite fears that the 1984 IRA bombing of the Grand Hotel would affect the conference trade, conferences have continued to bring in ever-increasing revenue to Brighton. The Tories continued to book Brighton for their conferences and an estimated 350,000 delegates and visitors came to Brighton just four years later in 1988. In that year, the conference trade was worth at least £53 million to the town.

The Brighton Centre.

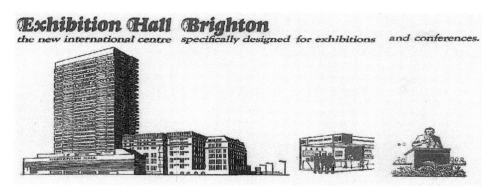

A brochure advertising the Exhibition Hall Brighton. Notice how the name 'Metropole' and its original buildings are reduced to a tiny and rather plain part of the complex in this picture.

The Brighton Centre was not Brighton's first conference and exhibition centre, as the Hotel Metropole, less than 200 metres away, had the town's first separate multi-function hall in the Clarence Rooms, which opened in 1890 (pictured in the 1960s). The Metropole's owners in the 1960s, AVP Industries, were the first to have purpose-built conference and exhibition halls in place by 1962, with 'Exhibition Hall Brighton' behind the hotel. Brighton Council acknowledged this and the increasing conference trade throughout the 1960s and 1970s finally getting architects Russell Diplock and Associates to build the architecturally criticised Brighton Centre using excessive textured concrete. It was opened by Prime Minister James Callaghan on 19 September 1977 and the style of building was soon copied by Bournemouth and other resorts. Brighton Centre remains the biggest of its kind in the south of England, however, with room for 4,500 concert goers and 5,000 delegates to conferences or exhibitions. Construction plans were thankfully scaled back, as it was due to have a massive tower block on top of it, which was wisely vetoed by Brighton Council.

Despite its unpopular brutalist looks, which have been described as unsympathetic to the surrounding Regency-style buildings and the Italianate Grand Hotel next door, it remains a remarkably popular venue. It alone was believed to generate £50 million for the town in 2004. This is despite being too small for major events today, with plans for relocation of Brighton's conference 'zone' to Black Rock. It still attracts major music and entertainment events, and has the dubious honour of hosting Bing Crosby's last ever performance on 10 October 1977, four days before his death of a heart attack. Additionally, on 11 September 2001, then Prime Minister Tony Blair received the news of the terrible catastrophe that was the terrorist attacks on the Twin Towers in New York while at the TUC Conference at the Brighton Centre. He changed his speech to reflect this event and the nation's media descended to record his departure after his speech. The building is past its best and has never been loved by Brightonians or fans of architecture, but has been an important Brighton building in financial, entertainment, political and historic terms.

8. Exhibition Hall Brighton and Conference Centre

The post-war extensions to what is today the Hilton Brighton Metropole are admittedly not a set of buildings that are in the least bit pretty, but the collection of buildings behind

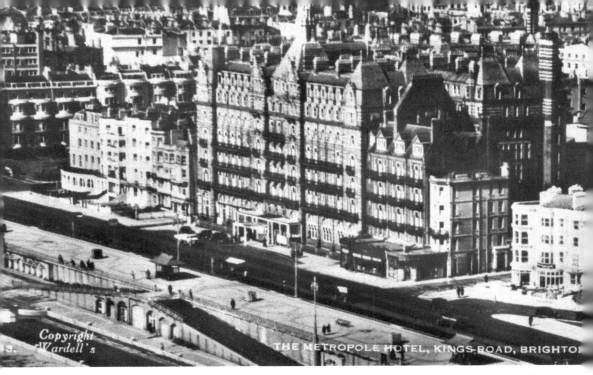

THE METROPOLE HOTEL, KINGS ROAD, BRIGHTO

Above: The Metropole before the changes to its roof and construction of the Exhibition Halls from 1961 onwards.

Below: The Metropole's Winter Gardens, replaced in the 1960s with exhibition halls and called the Regency Suite today.

Inset: Further plans for the east side of the Metropole that never materialised but give some ideas as to how a competitor for a Black Rock conference centre could operate.

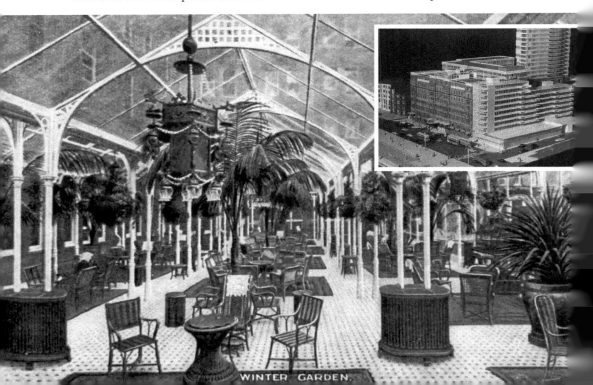

WINTER GARDEN.

the Metropole Hotel are important to the story of Brighton's changing role in the twentieth century and have had some amazing visitors.

The building of the separate Clarence Rooms in 1890 within the Metropole's grounds demonstrated that the hotel's first owners, Gordon Hotels already had their sights set on multi-purpose venues that could be hired by visitors to the town, Brighton organisations and businesses. It was to be in the 1960s that the hotel would gain its extensive rear annexe, though. Originally called 'Exhibition Hall Brighton', but with no official collective name today for its numerous exhibition halls, the Hilton group not only own the Brighton Metropole but the south-east's largest residential conference and exhibition centre. This group of buildings was not only the first of its kind in Brighton but arguably helped to develop Brighton into a modern conference venue and therefore rescue the town from the economic doldrums it faced by the mid-1950s. By the time of post-war austerity, Brighton's Victorian and Georgian hotels were all feeling the effects of age, under-investment and wartime neglect. Brighton was also losing visitors and income rapidly as holidaymakers started to desert for cheaper package holidays abroad.

Harold Poster, the hotel's owner from 1959, ordered the building of the Exhibition Hall by R. Seifert and Partners, who were also to build the 300-foot Sussex Heights tower block as part of the exhibition complex. This also helped saved the hotel by realising that Brighton's future lay as a conference location. Conference delegates and exhibitors would want high-class nearby accommodation, which would ensure high-class visitors to the hotel's newly improved rooms. Thus Brighton's first residential conference and exhibition centre was born – the Metropole, with all the required amenities located onsite. Brighton also appealed as it was an exciting place to hold such events, away from the London smog of the 1950s, with easy access to Gatwick or the ports, with the European Market becoming an increasingly important feature to Britain. It was also a place of culture, entertainment and history for delegates and exhibitors.

Poster had witnessed exhibitions becoming vital in the 1950s consumer boom with British manufacturing once more on the increase. Technological advances during the Cold War were being felt in the consumer sector. Companies needed bigger and more platforms to demonstrate these advances or the latest consumer products to both domestic and international markets. Political parties and trade unions all saw rises in membership post-war, bigger venues were also needed to hold their new, larger conferences and the Metropole has hosted many of these since for over fifty years.

Completed by the middle of 1964, 'Exhibition Hall Brighton', coupled with the country's first licensed casino, featured many exciting events. The first ever 'Disc Festival' – as played by 'Disc Jockeys' – in other words a records and music fair, took place on 21 August 1962 in some of the first halls completed. Britain's first ever fast food fair also was at the hotel, as well as the country's first exhibition for the greetings card industry. The latest technology meant the Metropole could even hold events organised from the US while delegates and exhibitors in the exhibition halls even got to travel up and down Brighton's first escalators.

The building of Exhibition Hall Brighton meant that the Metropole offered four times more exhibition and conference floor space than the council's only alternatives at that time, the Corn Exchange, or the Odeon/Ice Rink in West Street. Being Brighton's first ever purpose-built conference space and a modern construction, it could offer new or unusual features for the time, such as air conditioning, CCTV, Brighton's first escalator and, intriguingly, 'a floor surface that is not tiring.'

The most exciting exhibition must have been that held by the Ford Motor Company in February 1967 (pictured) when the company decided to publicise its annual staff awards with a trip to Morocco as a prize for the top salesman. The company decided to bring a real-life camel, Sheena, into the awards to raise the excitement further. Unfortunately, Sheena never made it that far. Obviously sharing in the excitement of the evening, she was unable to contain herself and decided to empty her bladder in the foyer. A quick-thinking general manager managed to save the honour of the hotel with quick reactions and a handy bucket!

AVP and subsequent Metropole owners further extended the exhibition space in 1972 and 1980–81, so it could be divided into subsections or merged into one large conference space. The increase in floor space to over 100,000 square feet by the 1970s was testament to the growing success of events in the Exhibition Hall years before the council's Brighton Centre, which was completed in 1976.

The price however, would be the destruction of a historic building, conceived by Brighton's most prolific and revered early resort-era architects, Wilds and Busby: St Margaret's church. This 1820s building stood where the entrance to Sussex Heights and the hotel's car park is now. It also meant the replacing of its little-used but once romantic Italian and Winter Gardens with conference and exhibition space, but without these vital buildings, Brighton would have lost numerous events, visitors, delegates and VIPs to other locations. By the 1960s the idea of coming to the sea to sit in a garden facing away from the sea with its view obstructed was bizarre, and the numerous tower blocks springing up around Brighton made the hotel's gardens a windy and less exclusive spot, so the developments were not only logical, but desperately needed by Brighton too. If the Brighton Centre today brings in £50 million in one year to Brighton alone, the financial value of the Exhibition Hall at the Metropole for over fifty years makes it being worthy of the title of one of Brighton's most important buildings.

It is rare to have a year now without one of the political parties appearing in Brighton, as well as trade unions, multinationals and other exhibitors. Prime Ministers have not only graced the valued Victorian edifice that is the Metropole, but the less glamorous utilitarian 'workshop' behind it. Today, the exhibition halls behind the Metropole still hold all the political conferences but also one unusual legacy. One Regency-style building in Cannon Place had to be preserved as part of the complex, which means its shell is still intact, but inside it has probably the country's most expensive staircase providing a fire escape for the halls inside. One of Wilds and Busby's 1820s buildings, the Assembly Rooms in St Margaret's place still have their exterior as part of the complex, a reminder that meeting and discussing have always been a focus of this part of Brighton.

With Brighton & Hove Council debating the demolition of the Brighton Centre and a new conference 'zone', perhaps the Metropole should fight back as the home of Brighton's first conference and exhibition centre. Although the 1965 plans to develop the Metropole's eastern side aren't to our tastes today and would have ruined the Victorian south face, perhaps they provide a suggestion as to what an entrance to a revamped Hilton conference and exhibition centre could be like. If Brighton Centre is redeveloped to provide a more pleasing use of the seafront, could we not have Brighton's premiere venue with an entrance in Cannon Place, facing the Grand and the road that has one of Brighton's founders, Richard Russell in its name? A massive modern exhibition hall need not take up any more space in central Brighton, even digging down below ground to provide Brighton with a 10,000-plus person venue it needs. On top, why not a new and exclusive rooftop Winter Garden?

9. Brighton Pier/Palace Pier

Originally, and still technically known as the Palace Pier (the Pier Society have never formally recognised the name change), the last existing pier in Brighton (there have been five overall) has survived many seaside shocks over the years and is the world's most recognisable pier. Built between 1891 and 1899 to replace the Chain Pier, the old pier nearly ruined its replacement when it collapsed in the terrible storm of 1896 and its debris collided into the new pier. Bits of the Chain Pier that deliberately ended up on the Palace Pier included the toll houses, which had been used as garden sheds in a park until moved onto the younger pier in 1934. As the Brighton Marine and Palace Pier (its original name and whose initials still appear on the pier's metalwork) owned the Chain Pier and was responsible for its demolition, they were also billed for the damage the debris caused by the rival West Pier and Volk's Railway.

If it had a troublesome time during its construction, with numerous financial problems, when the Palace Pier opened it was an overnight success. The Palace Pier was first lit up on its opening day in 1899 with 3,000 lightbulbs, and it was a place where stars also shone; the Palace Pier's theatre was an early venue for the worldwide legends of comedy, Stan Laurel and Charlie Chaplin, both of whom played there before finding huge fame in Hollywood. Their show, *Casey's Court*, would help them find fame in the US. However, by 1914 it risked being lit by a different type of light as the surrounding area was defensively mined, ready for detonation should the German navy tried to invade. It was mined again in the Second World War, where errant explosions caused some damage to its land end. By the 1940s the Palace Pier had become the second home of the Aquarium's clock tower, moved in 1929, where it remains at the entrance to the Pier still today. Its workings were removed in the Second World War for safety, which was lucky as the 1941 explosion of defensive beach mines damaged not only the pier but its new clock tower. The Second World War also saw it cut in half so it couldn't be used as a Nazi landing platform and left to rust without maintenance for five years. Nazi dive-bombers also caused damage – the East Pavilion Sun

The Palace Pier in the early twentieth century.

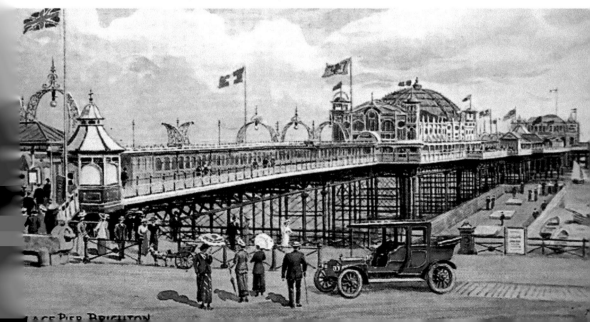

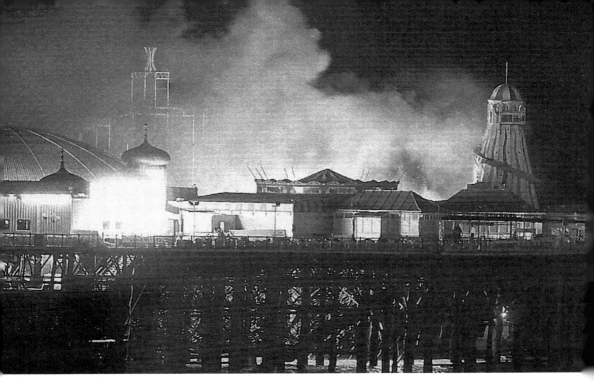

Ghost Train fire on the Pier, 2003.

Terrace was mauled by German shrapnel. Other, sadder war casualties linked to the pier were the paddle-steam ships *Brighton Belle*, *Brighton Queen* and the *Devonia* that used to dock to pick up passenger for voyages. All three were destroyed while being used as rescue boats among the heroic flotilla at Dunkirk in 1940.

Even in peacetime, its oriental-style Pavilion Theatre had to be demolished in 1973 when a barge being towed nearby broke free and damaged a huge chunk of the sea end of the pier. Thankfully it was restored, yet it faced more potential destruction on 21 January 1980 when the huge *Athina B* coaster beached only 500 yards away, and on 16 May that same year a Red Arrows jet crashed into the sea near the pier. Even in the noughties, the pier faced serious damage when its Ghost Train caught fire.

In the 1980s the then leader of the Labour Party, Neil Kinnock, was the first to accidentally predict the name change when he addressed the House of Commons in 1981. He said: 'Like Brighton Pier, all right as far as it goes, but inadequate for getting to France.' The pier's original name was because of its position facing the Royal Pavilion, although the West Pier could have claimed the name 'Palace Pier' first as its builder, Eugenius Birch was inspired by the Royal Pavilion's oriental grandeur and it originally had a pavilion on its sea end too.

The Noble Organisation, who bought the Palace Pier, were tasked with rebuilding a similar-looking theatre building to the demolished one at the sea end of the pier as part of their purchase agreement in 1984. This was meant to have been completed by the year 2000. They invested heavily in the pier however, making it free to enter, increasing the number of entertainments on its deck and maintaining the superstructure well.

Today, as it approaches its 120th birthday, Brighton Pier has a new owner and is a successful showcase of the traditional, more lowbrow side to Brighton's seaside success story.

It entertains all visitors to the town and is one of the country's busiest tourist attractions, but especially appeals to the traditional seaside day-trippers and holidaymakers. It makes no attempt to embrace Brighton's 'boutique' side, being happy to entertain the twenty-first century equivalent of the 'bucket and spade brigade'. This is why it is especially apt that the epitome of seaside postcard humour, the *Carry On* films had two of their collection filmed on the pier. *Carry on Girls*, where the town's name was changed to the ruder 'Fircombe' (say it out loud) and *Carry On At Your Convenience*, both involving excursions onto this iconic British seaside landmark. It is acknowledged to be the finest pleasure pier ever built and no brochure or website about Brighton is complete without it.

1c. Brighton Station

The idea of a railway to Brighton from London was first seriously discussed in 1823; the current location was the winning choice of five that the town in the late 1830s were investigating. Others included a terminus near Brunswick Town and also where Park Crescent is today. The hilltop location, built on a man-made plateau 130 feet above sea level was chosen as it meant steam trains wouldn't be adding to the smoky air down in the town, but instead the downland air would blow the fumes away. The hustle and bustle of the area around David Mocatta's fantastic 1841 railway station building today means we forget this was a remote, rural location when first built. The success of the station not only brought endless tourists to Brighton, but allowed Londoners to commute from here or Brightonians to find work in the capital. It meant that Queen's Road became a developed thoroughfare and the road extended over Trafalgar Street to the station and the fields to the north, east, south and west of the station became new railway workers' houses. Employment was created through the jobs associated with a busy station and railway company headquarters, as well as the new Railway Works building engines next to it. As royalty departed from Brighton, the station brought replacement wealth from the lower rank in society, but in greater numbers, saving the town's economy.

Brighton Station grew as the town grew, stretching out to the south, east and north. Its first line was not to London, unbelievably, but to and from nearby Shoreham instead. Once the London lines opened, the station developed its own grand glass and metal railway sheds in 1882 and 1883 as it expanded, creating a graceful construction as they curved around the lines following the hillside route through the downland cutting for the train lines. A less-pleasing metal canopy protected visitors entering or departing from the station's south front but obscured Mocatta's graceful early Victorian building, which still contains the boardroom and offices of the London, Brighton and South Coast Railways, whose head office was based here. A goods terminus and line developed below and to the east of the station, creating an additional line and station in New England Road. Brighton soon developed other subservient stations at London Road, Preston Park, Kemp Town and across Hove. Brighton Central Station, as it was originally called, became just Brighton Station in 1935. Brighton became not just an end of line destination but a metropolis where you could travel between its suburbs by rail and cross-town commuting became a way of life.

Being high up on the town's hills had its disadvantages however, as horse-drawn carriages couldn't make it up what is today the still-very-steep Trafalgar Street and so a less-steep roadway was built under the station from Trafalgar Street to Platform 7 (6 today) which

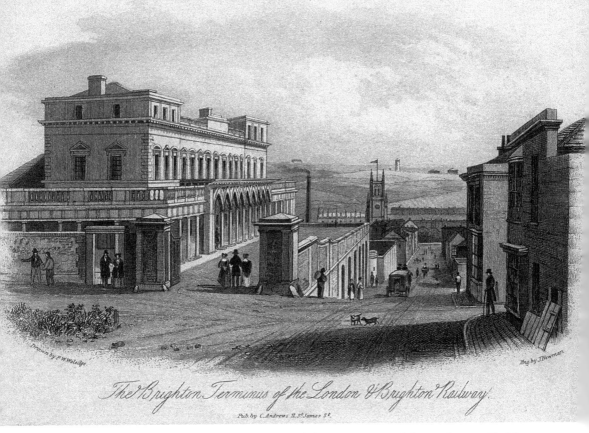

The Brighton Terminus of the London & Brighton Railway.

Drawn by F. W. Woledge. *Eng by J. Newman.*

Pub. by C. Andrews 11. St. James St.

Brighton Station before its 1880s additions and the construction of the road across Trafalgar Street.

is still there but well hidden. It can still be seen if you look down through the wooden floorboards to the east of the station and through the two large wooden doors next to the toy museum. This narrow road came up where Marks & Spencer store their trolleys today and is unfortunately blocked at this end. There is a second tunnel, now mostly filled in, which became important during the Second World War as it was underground; until recently it was home to offices and a local rifle club. British Rail's plans to demolish the station building in the mid-seventies and replace it with a hideous concrete hotel helped to rally Brighton's wonderful Regency Society, who went on to help save North Laine and countless other priceless Brighton buildings.

After much restoration, simplification of layout and preservation of its Victorian heritage in the late twentieth and twenty-first centuries, the station is now looking better than ever, surrounded by the busy New England Quarter, rather than ramshackle car parks and urban blight as it faced from the 1970s. It is the seventh-busiest station outside of London today, with over 17 million passengers passing through Mocatta's Italianate building in 2014/15. Although the front 1880s canopy has much architectural merit, with twenty-first century glass technology, surely when it needs replacing we could have a near-invisible canopy at the entrance that reveals the original station building (pictured) in all its grandeur once more? This would be a great way to celebrate the plans for Brighton to be linked directly to Cambridge by 2018 as well as another marvellous Victorian station, London's St Pancras.

11. Brighton Town Hall

Despite numerous plans to replace it (one of which is pictured), Brighton's Town Hall is an unusual surviving example of classical architecture, designed in 1830–32 by Thomas Cooper, who also designed the better-proportioned, but now sadly replaced Bedford Hotel. It looks as if someone has built one Greek temple on top of another, but it remains a charming and intriguing building, both internally and externally. Like St Bartholomew's church, it was planned to be even bigger, and in the form of a Greek Cross. However, land disputes meant the town commissioners could not build the southern wing of the cross, so it remains an unusual shape today.

It is not Brighton's first town hall, but unlike neighbouring Worthing, Brighton has never had to hold its town meetings in a series of pubs. As befitting a seaside town, the first 'Townhouse' was on the cliff top, between Black Lion and Ship Street, east of the Blockhouse, and had existed since at least the 1580s. An early relationship between Brighton's market and the town hall existed from this point, as the current building was neighbour to a market for many years. Like the Blockhouse, the sea eroded it away and by 1727 a replacement (the first to be titled 'Town Hall') was on the west side of Market Street, where Bartholomew Square is today. This was used as a workhouse, meeting place and a embryonic Police Station before being demolished in 1823 and the current Town Hall built. It replaced a later Brighton market and is on the site of Brighton's priory, which was destroyed by the French in 1514. It is reputedly haunted by a ghost on the elaborate staircase, and is also the site of the murder of Henry Solomon, Brighton's first Chief Constable, who was battered to death by a villain with a poker in the building.

It is also a special place in Brighton's literary past as Dickens used to do readings here (as well as at the Old Ship Hotel) and, jointly with the Pavilion, it hosted Brighton's first conference in 1853. It also used to be the centre for election result announcements.

The plans to replace Cooper's Town Hall plans that were thankfully never implemented.

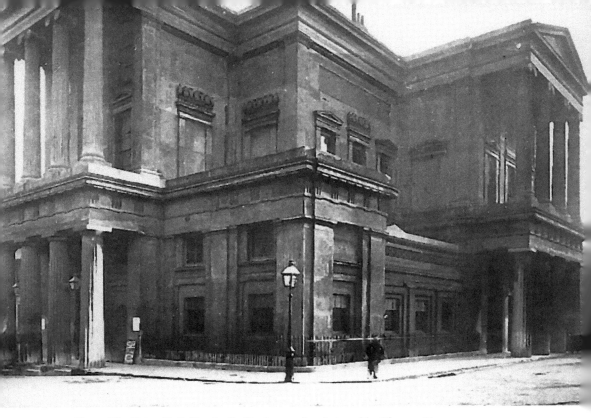

Above: The Town Hall, like the Bedford, was also designed by Thomas Cooper.

Below: Election time announcements at the Town Hall – an event needing resurrection.

For years those elected to serve the council deliberated whether to knock it down and build a much-needed new town hall but couldn't decide on a site – one councillor even joked about putting it on wheels so that it could be moved around until they decided! As the Town Hall was too small to cope with the needs of local government for a place of Brighton's size, Brighton Council has been spread around the city for many years now but thankfully replacements were never built, and the councillors finally agreed that the current beautiful Town Hall would remain at the heart of these buildings. Extra council office space was built into the Ramada Renaissance/Bartholomew Square development of 1987 to house council staff. The Town Hall is now the centrepiece of that development, something that seems to protect the building by having it as its centrepiece.

Unlike our poor neighbour Worthing, we still have our original Town Hall and it is an excellent building, not only listed but still much used as a marriage venue, tour venue, museum and of course the heart of local city democracy.

12. Chain Pier

Some metalwork, a signal cannon and kiosks on Brighton Pier are the only above-surface remains of Brighton's first pier – and the country's first ever pleasure pier. Built by a naval captain and engineer, Samuel Brown in 1823, the Chain Pier took its name from the chains that helped hold it up to the pillars that were part of the structure. It was then also chained into buildings across what would become Madeira Drive, which was much narrower at that point and only went as far as the pier. It was accessed via an entrance of toll booths that would become the site of the Aquarium, from where visitors would walk down a private esplanade to access the pier. Alternatively, from the New Steine there was a series of steps down the cliff face. It would be the third pier in the country after Ryde on the Isle of Wight and Newhaven in Edinburgh.

The Chain Pier – a seventy-three-year wonder and only the third pier ever built.

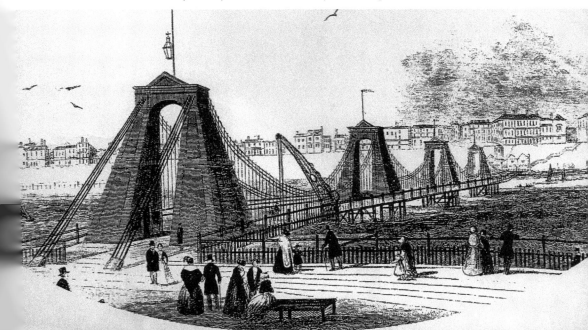

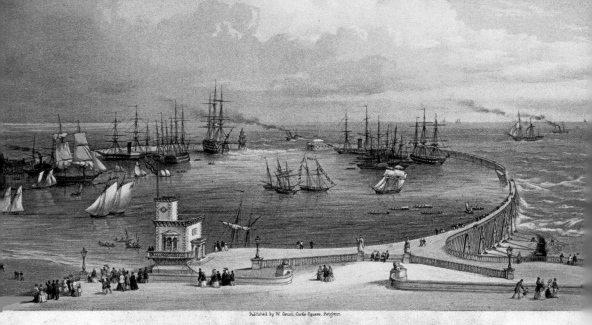

VIEW OF THE INTENDED HARBOUR AT BRIGHTON, ON THE RECOIL PRINCIPLE.

Plans to use the Chain Pier as part of one of the early plans for a Brighton Marina. (Courtesy of Royal Pavilion and Museum, Brighton & Hove)

Piers were originally jetties to allow boats to dock and unload increasing amounts of goods as Brighton's 'harbour' (as much as it ever had one) had disappeared long before the Chain Pier's construction and Brighton needed to import much of its goods by sea until the railways came. Brighton was even a busy official port at the time of the Napoleonic Wars and part of its attraction to visitors was its busy service of ships to Dieppe. Starting life as the Royal Suspension Chain Pier, it was an embarkation point for travellers, then a promenading pier, and with the first amusements and activities, the country's first pleasure pier. Using chains to help build the Chain Pier back in the early 1820s as a suspension pier was an example of the latest building techniques at the time. It was also very fortunate for its engineer, Captain Samuel Brown of the Royal Navy, as he was the owner of a company that supplied large chains used for ships' anchors. His chains ended up as the chains of the Chain Pier, which ended up costing £30,000 to build.

Once opened, it became a success with visits by William IV and Queen Adelaide, who would throw sweets to local children on the pier, and Queen Victoria's famous 1843 visit to Brighton commenced via the pier. Turner and Constable were both inspired to paint the pier and it remained a celebrated part of Brighton until its destruction by storm in 1896. Its destruction damaged both the Palace Pier (then under construction), the West Pier and Volk's Railway, but its popularity over its seventy-three years led to the development of its successors, one of which still survives today. Greater Brighton even at one point had five piers in 1896 as two more piers were also built at Ovingdean and Rottingdean to support the 'Daddy Long Legs'. Its successful construction over the sea gave Brightonians and visitors the chance to view the town from the sea and also led to further plans for artificial harbours, ranging from this 1830s fanciful plan (with the Chain Pier pictured on the left) to eventually the 1970s Brighton Marina.

13. The Chattri

For a place that fighting avoided in the Civil War and only saw invading armies from Roman to Norman times, Brighton has a number of servicemen buried here – and at least one servicewoman. Our cemeteries in Bear Road include a number of First and Second World War dead, or those who died after the war but had served, including my own great-grandfather. Some of these are from air raids, accidents or where servicemen had returned home but died from their injuries. There are some graves you would not expect, however. Bear Road Cemetery has a number of German air force graves from the Second World War and valiant Sikh and Hindu Indian soldiers who died while being treated in Brighton hospitals had their cremated ashes buried up on the Downs near Patcham at the Chattri memorial. This building is well worth the walk today from Braepool or the Jack and Jill windmills and provides an amazing view of Brighton. Today it is a registered war grave but was disrespectfully used for target practice during the Second World War.

Meaning 'umbrella' in Hindi, Punjabi and Urdu, Brighton's memorial and war grave for those Indian soldiers that died in Brighton can be seen from the A27 up on the Downs, north of Patcham. The white, dome-topped construction on top of a white set of steps and platform is now officially looked after by the Commonwealth War Graves Commission. It lists all the names of the soldiers who were cremated and is a poignant reminder of the sacrifice made by the 1 million Indian soldiers who fought for the British Empire in the First World War. It was unveiled in 1921 in an opening ceremony by the Prince of Wales and is matched by another Indian-style building at the Pavilion from this era. The year after the Chattri was built, the Pavilion's southern gate was replaced by the gift of the India Gate in a gesture of thanks from the people of India to the people of Brighton for their care given to Indian soldiers during the war. Both the Chattri and the India Gate are now treasured monuments of Anglo-Indian relations, with the Chattri a Grade II listed building. Every year a memorial service is held there to remember these gallant soldiers.

The annual remembrance parade at the Chattri.

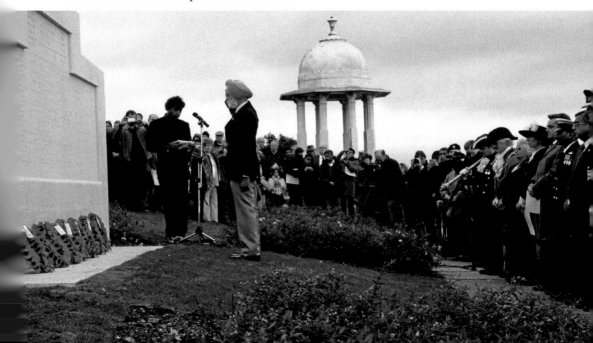

14. The Clarence Rooms/Suite

As well as blessing Brighton with the Metropole, his one and only seafront hotel and public building, the famous Victorian architect Alfred Waterhouse also endowed Brighton with a chapel and ballroom that we still have today – a well-kept Brighton secret.

Waterhouse designed the 'Clarence' Rooms as part of the Metropole's Italian gardens what were once the spot for wealthy visitors to the hotel to take romantic walks in. The gardens were lit, which was unusual, but the chapel and ballroom were where romance went a step further with dances, 'Cinderella' balls and even weddings. The Clarence also boasted an annexe, the Octagon Room, with an adjacent 'crush' room for ladies to presumably escape the crush of the ballroom and enjoy a quiet cool drink. These adjacent rooms are known as the Lancaster Suite today, but were for a while simply known as the 'North End' rooms, as they were, at that time, as far north as the hotel extended. The building is today surrounded deep within the collection of conference and exhibition halls in the Metropole Hotel complex. It was originally flanked by the hotel's Italian Gardens on two sides and part of its design included an enchanting late Victorian red-brick and terracotta clock tower, demolished when the hotel needed to build over the obsolete gardens in 1962. The Clarence became the centre of new exhibition and conference rooms built over the hotel's gardens as well as other buildings as the hotel expanded. As it was such an architecturally beautiful part of the hotel, no exhibition halls, nor thankfully Sussex Heights, were built on top of it.

It was built on the space once occupied by a drill hall, and took its name from nearby Clarence Square (1807) which in turn celebrated the impact the Duke of Clarence

The Clarence as it looked soon after the Metropole opened in 1890.

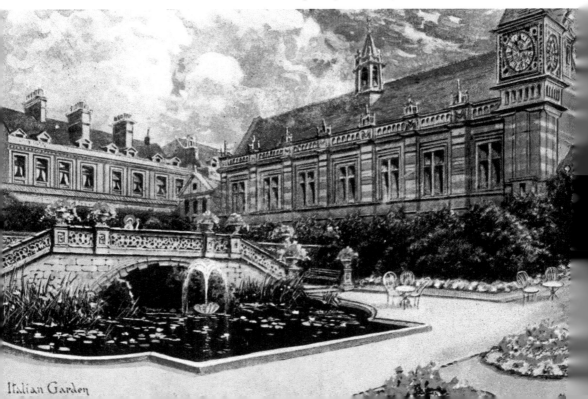

Italian Garden

(who became William IV) had on Brighton. It played an important role on the hotel's open day as the hotel's chapel and its rafters were filled with the music of the Metropole's very own band, playing to the first visitors and guests. Its design was very forward-thinking for the time, with a prediction of the hotel's conference role the following century. The concept was that the Clarence was a separate ballroom from the hotel that could be hired for weddings and meetings too, with its own separate entrance in Cannon Place, so as not to need to disturb hotel guests after late-night functions.

Late-night functions weren't always an issue however, with one of the room's first functions being a charming 'Cinderella' Ball held by the men of the Middlesex Yeomanry Cavalry, the idea being that the guests all had to leave before midnight. The earliest hire of the room was an 'At Home' party, hosted by Mr and Mrs Campbell of 16 Eaton Gardens, Hove in January 1891.

The Clarence's role changed and Brighton gained worldwide prominence and fame when the building became the location of the country's first licensed continental-style casino, following easing of the gambling laws. On its opening in 1962, the casino was painted blue and gold and was visited by a large number of VIPs. Its most famous first visitor was none other than Ian Fleming himself, no stranger to casinos as the author of the James Bond novels, including of course, *Casino Royale*, which had recently been published. £500,000 was won and lost in the casino's first fortnight and by 1967, it was still taking the staggering sum for that time of £70,000 per night. The casino's most glamorous would-be visitor was blonde British actress, Diana Dors, who was banned from entering the casino. The reason? She was wearing trousers. The 1960s bouncers were so strict they still refused to let her in, even when she generously offered to remove them.

The casino moved to nearby Preston Street in 1985 and the Clarence Suite, as it is known today, returned to being a function room. It still has a legacy of its gambling heyday with the safe built into the room, which cannot be removed without demolishing the Victorian building (or the detonation of a large bomb).

It is the only part of the massive Metropole complex to have retained its original name throughout its 126 years, still serving a vital role in the city's functions today, whether for parties, weddings, business meetings or conferences and is still the heart of Brighton's first conference and exhibition centre. Today it looks set to be the centrepiece of a multimillion-pound development planned by the council to regenerate the eastern side of Brighton seafront.

15. The Shelter Hall/Concorde 2 and Madeira Lift

Not many Brightonians know that the proper name for this amazingly cosy but successful music venue is the Shelter Hall and that it has a working lift that can take people up to Marine Parade from Madeira Drive. The lift is also properly known as the Madeira Lift. The venue has a capacity for 540 music lovers, has recording facilities and is a licensed venue for weddings. It would be a very wet venue if Madeira Drive hadn't been built and the beaches extended as originally the waves used to lap up to the cliffs where the Concorde now is. Inside and above it is the town's second attempt at building a lift that ascended up the East Cliffs, the first being by Magnus Volk, of the Electric Railway fame. He built a more westerly one at his own expense until opposition forced him to abandon the project, leaving him £500 out of pocket.

Front Elevation of
Madeira Lift Kiosk 1990

Left: The Madeira Lift, part of the Concorde 2 music venue. (Courtesy of Royal Pavilion and Museum, Brighton & Hove)

Below: The front entrance of Concorde 2 – or the Shelter Hall as it was once known. Viewed from the east end of Madeira Terrace.

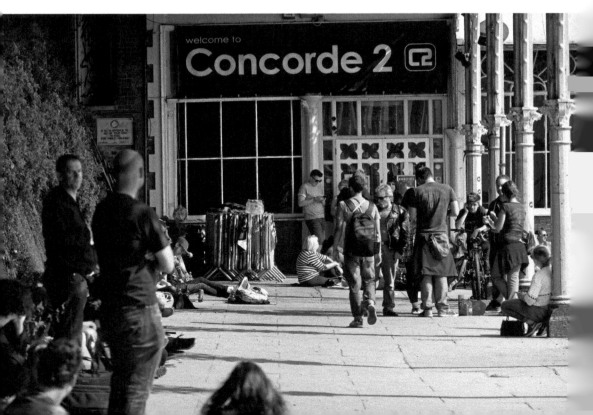

16. The Cricketers

The Cricketers has never been near a cricket pitch but takes its current name from the landlord, Mr Jutten, a cricket fan who renamed it from 'The Laste and Fish Cart' in 1790, a laste being a measure of 10,000 fish. Fish were not the only creature associated with the pub as its side bar was once the town's dog pound for lost or missing dogs. It was once owned by Deryk Carver, the famed Brighton brewer who also owned the Black Lion Brewery next door, recreated as a pub today. As well as quibbling with the Druid's Head as to which is the oldest pub in Brighton (it claims to have opened in 1547), it is known for its literary and possibly criminal past, as well as being frequented by actors such as Sir John Gielgud, Lord Olivier, Arthur Lowe, Richard Briers and Ralph Richardson.

Graham Greene wrote probably the most famous ever book about Brighton, *Brighton Rock*, and one of his other books, *Travels With My Aunt*, also features the Cricketers, which is why it has its own 'Greene Room' today. Greene also stayed at the Metropole and the Royal Albion, both of which he wrote in, and it seems the Metropole was where he wrote at least a part of *Brighton Rock*. The Greene Room also features Jack the Ripper memorabilia as one the pub's guest rooms were stayed in by Robert Donston Stephenson, a journalist, black magic dabbler and trained army surgeon whose ghost allegedly haunts the Cricketers. Stephenson also lived above the pub in Black Lion Street in the first half

The Cricketers, a haunt of ghosts, Greene's characters and possibly Jack the Ripper?

of 1888, in the year of the murders, and the pub was a well-known haunt for prostitutes. Stephenson was linked to murders, including one in the Royal Albion hotel in the city, but moved to Whitechapel on 26 July 1888. Just days later, the first of the Ripper's prostitute victims was found dead in a side street. Stephenson was one of the prime suspects and remains one. The Cricketers may have been therefore the place where the Ripper planned his grisly murders, but to Graham Greene, it was his 'best loved pub' and remains so for many Brightonians today.

17. Dome/Brighton Museum and Corn Exchange

These three buildings together comprise two entertainment venues today and Brighton and Hove's main museum. They were built as Prince George's stables and riding school, as the prince liked to race his horses at the Race Hill at Whitehawk. When the Dome was first used for Indian soldiers in the First World War, the water trough in the middle needed to be removed. At one point in the early 1800s, more money was spent on these buildings in one year than on education for the whole country. Older than the Royal Pavilion and the first buildings in Brighton to be built in an Indian style, the Dome and Corn Exchange actually helped inspire the prince to build the Pavilion. The Dome and Corn Exchange cost £55,000 and were actually first built between 1803 and 1808 by Henry Porden,

The Dome when it was first built as the Prince Regent's riding school.

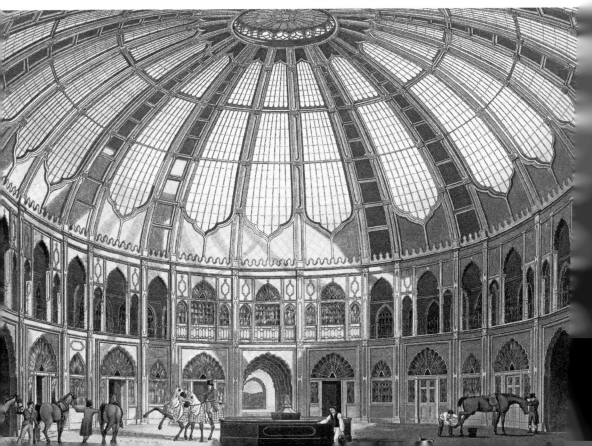

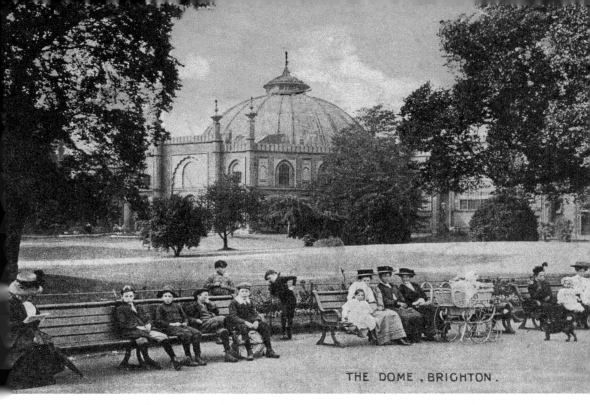

THE DOME , BRIGHTON.

Above: Exterior of the Dome in the early twentieth century. Now a music venue and museum, its Indian styling came before the Pavilion and inspired Prince George to redesign his holiday home.

Below: The Dome in 1974, getting ready to host Eurovision, where Abba would sing about Waterloo, a battle that the building's original owner used to (incorrectly) brag about attending.

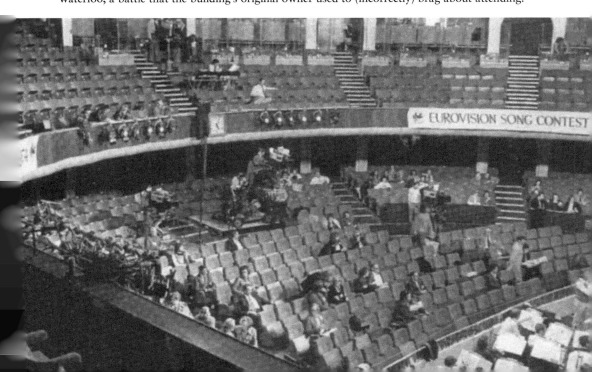

whereas the Pavilion only received its Indian styling between 1815 and 1822. Porden was inspired by the Paris Corn Market, which is therefore fitting that the smaller concert venue of the complex has been called the Corn Exchange since 1868. Brighton's Corn Exchange before that had been at the King and Queen pub. When completed, George was so pleased with the styling of what is now the Dome that he insisted his Marine Pavilion (built by Henry Holland) was redesigned to make a matching set by Nash, giving us the building we have today. Porden was a very sick man by that time and Nash was very in fashion, having designed what would become called Regent Street and other fashionable parts of London. The dome on the Dome was one of the biggest in the world when it was built, and likely inspired the prince to insist the Pavilion should have its dome too. The phrase 'the Dome' started to be used around 1864 and it received electric light to replace its gas lamps in the 1880s, installed by none other than Magnus Volk, who was told by Siemens, one of the world's leading electric firms at this time, that it was the world's biggest installation of incandescent light.

The Dome and museum have a secret tunnel to the Pavilion, which is marked by a series of circular glass windows on their roof, which you can actually spot when you look between the Pavilion and the museum on the ground. This was created so the prince could move between his home and stables without people seeing him in years of increasing girth, and it was also used by Queen Mary over a century later in the 1920s, who requested a special tour. The Royal Pavilion used to do tours of this tunnel too, but have stopped them of late and are focussing currently on the Pavilion's role in the First World War instead. Although people think of the Pavilion as being where Indian soldiers were treated during the First World War, it was actually the Dome too, with the whole complex being surrounded by a high wall to keep curious Brightonians from peering in – and the more recovered soldiers from visiting Brighton's prostitutes!

Some other foreign visitors who were made equally welcome were bands from all around the world and of course, the Eurovision song contest was famously held at the Dome in 1974. Abba won with 'Waterloo' as the world watched. One of the world's most famous bands made their name in a building designed for a different type of competition. Like another famous dome, the Millennium one (as it was known before it became the o2 arena), it is interesting that the Dome in Brighton shared its fate of being turned into an entertainment venue, although has thankfully been allowed to keep its original name.

18. Embassy Court

Embassy Court is a bizarre snapshot of what Brighton might have been had Mayor Herbert Carden's plans to demolish all the Regency-style architecture along the seafront been achieved. Carden really did want the whole seafront to have the same art deco style as this controversial but now much cared for block. Built in 1936, it was the first modern tall residential building in the city at eleven storeys. It can be criticised for being so much plainer than its Brunswick Terrace neighbours and insensitively placed next to such a different style of architecture. It can also be argued that it led the way for the horrible 1960s buildings that plagued the town. However, Embassy Court is loved by its residents and, since its renovation, looks as it did in its heyday. It is not architecturally horrible, perhaps just misplaced, and was awarded a listing of special architectural interest in the 1980s. Rows of Embassy Courts would have been wonderful, but not in place of our even more beautiful Brunswick Town.

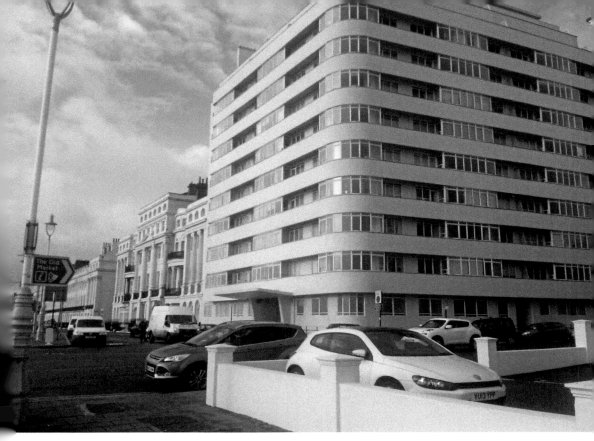

Embassy Court: a wonderful building but a misplaced location.

19. The Grand Hotel

Brighton's first truly exclusive 'superhotel' was built in a mix of classic Victorian and Italian styles between 1862 and 1864. It was designed by John Whichord and its stone carvings and rich plaster embellishments were created by the sculptor Adam Gamle, who had worked on Buckingham Palace and the Houses of Parliament. Its 150 rooms (then the biggest in Brighton) were built on the site of the old artillery barracks and you can still see the curved road that ran behind the cannon of the barracks – it is today the driveway in front of the Grand. This is also why the road between it and the Metropole is called Cannon Place. During its 1986 rebuilding, the *Argus* reported that the builders found 'holes near the original foundations that had to be filled in' from the original barracks. The *Argus* also ran a competition in 1980 for readers to name the new bar in the Grand's now next-door neighbour, the Metropole that is today the Salt Room. They chose the name of 'The Cannon' to reflect the pub's location near to the former occupier of the Grand's site.

The Grand was a technological marvel when it opened in 1864 and cost £160,000, nearly three times as much as the Metropole. This was because much of the technology required in order to construct such tall buildings was in its infancy. It was also a massive building for its time, needing 3.5 million bricks to help construct its nine floors, fifteen miles of wallpaper, six miles of gas pipes and twelve miles of bell wire. It kept ironworks

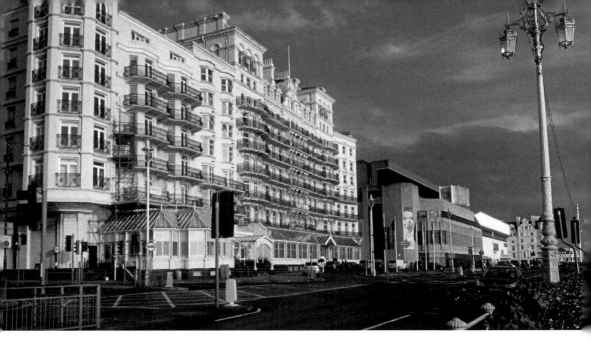

Above: The Grand Hotel today. Like the Metropole, it has lost its symmetry and the two hotels, once a distance apart, have been extended towards each other to the point where they are nearly kissing cousins.

Below: The Grand after the IRA's bomb exploded in October 1984.

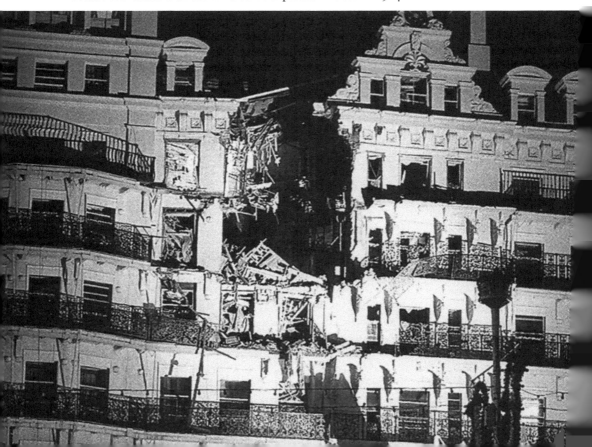

busy in the 1860s, using 450 tons of wrought and cast iron for the staircase alone. It had the latest in technology in a water-powered hydraulic lift – or 'ascending omnibus' as it was then called. Amazingly for the 1860s, it had electric power throughout the building, and all of these technological wonders meant it attracted the brightest lights of the Victorian age, including Napoleon III and Prince Metternich. Even in the twentieth century it was blessed with some famous names, including the Duke of Windsor, JFK and Ronald Reagan.

Today it is hard to believe that the hotel was threatened with destruction by town planners and the British Corporation from 1959 (see Kingswest Boulevard) as plans to redevelop the streets west of West Street as part of what of what ended up as the Churchill Square development. Thankfully, the hotel's demolition and replacement with an amusement centre was voted down. It came much closer to total destruction however when it received a horrible 120th birthday present in the form of an IRA bomb. The Provisional IRA had planted the bomb, aiming to kill Margaret Thatcher and her cabinet, and on 12 October 1984 a large explosion tore through the building, killing five and wounding thirty-one. This was the result of a long-term delay detonation timer, set three weeks before the explosion. The IRA bizarrely even used the timers on VHS video recorders in this sort of bomb at this time. What was amazing was the fact that, although the bomb caused tons of masonry to fall down, the Union Jack flag that had flown for eighteen years on the hotel's roof until that night refused to fall down, although the flagpole precariously straddled the gaping hole left by the explosion. Today, visitors wanting to see Room 629, where the 20 lb gelignite bomb was planted behind a bath panel, will be disappointed as it was redesigned as part of a number of totally new luxury rooms and renumbered.

The Labour Party moved to the Waterfront Hotel (then the Ramada Renaissance) in the following years after the bombing but have since moved back to the Metropole, also using the Grand when holding their party conferences in the city. The Conservatives returned to the Grand with both Margaret Thatcher and John Major staying there once it was rebuilt. The IRA bomb failed to dent the city's conference trade, and today there are plans for a new conference centre at Black Rock.

Ironically, the Grand Hotel's front entrance and bar had just undergone a refurbishment in 1984 when the IRA bombed the hotel. The hotel was due another huge renovation of its Empress Suite, lounge area, bar, King's restaurant and other function room. After the bombing these never went ahead; the money was used instead for a £10 million rebuild and refurbishment and was enlarged by 1992. It saw prices rocket to help pay for renovations – the Presidential suite went from £190 to £250 a night, the former not too far off the average price of some hotel rooms today! The next-door Metropole took in all the guests and managed to serve them, the emergency services and the press an extra 2,000 breakfasts that morning. Smoke-blackened and shaken visitors to the town were found clothes, towels and razor blades, as some of them had lost their clothes and toiletries in the blast.

Despite the noise and chaos, one American reporter managed to sleep through the entire event just 100 yards away in the Old Ship Hotel. As his colleagues from all over the world hunted for interviews, filmed survivors and photographed the devastation, the highly paid reporter of the *Washington Post* slept through the entire night. Unlike the scores of reporters flocking to the scene, his sleep was uninterrupted, and he only found out when he rang his newsdesk in America. On being asked when he was going to file his story on the bomb, he spluttered 'What bomb?' and had to stagger half-dressed into his hotel lobby to ask what was going on.

Since 1984 the Grand has recovered, been rebuilt, extended and improved, and as a result, was voted one of the best hotels in the world by American Express card members in Britain in 1991. It came fourth in the country and was the only hotel outside the capital to be recognised. The Grand has also been a leading choice for a filming location, with 1992 being its peak year. In that year, the British version of the show *House of Cards* was filmed in the town, involving sixty extras, many of whom were dressed as police officers pretending to be at a Conservative Party Conference based at the Grand.

Also in 1992, the series *Natural Lies* with Denis Lawson was filmed at the Grand, with stuntman Terry Forrestal assuming the role of one of the characters committing suicide by jumping from room 621 (previously 629). No one had told Terry that the renumbered room in question was actually the ill-fated room that the IRA bomb had exploded in eight years earlier. The same hotel was used by *Only Fools and Horses* in the same year when Del Boy and Rodney made it rich selling fake 'Peckham Spring' water (which was also filmed in a Brighton allotment). Del Boy appears in one of the Presidential suites with Raquel on the balcony.

Overall, five television productions were filmed at the Grand in 1992. As well as *Only Fools and Horses*, others included Ian MacShane's *Lovejoy* and other 1990s sitcoms *Waiting for God* and *Brighton Belles*, a British remake of *The Golden Girls*. Two years later, the hotel was visited by Keith Chegwin in his comeback era when filming live television broadcasts for Channel 4's *The Big Breakfast*. Today the hotel remains part of Brighton's conference zone as well as a recognisable and much-loved face of Brighton.

20. Hilton Brighton Metropole

It is hard to imagine Brighton without its red Victorian wonder, the Hilton Brighton Metropole on the seafront. The site was formerly a roller-skating rink, customs house, shops, drill hall and twelve lodging houses on the King's Road. The area was called the West Laine Cliff Butts area of Brighton and Brighton Corporation (today the council) tried to turn it into a Winter Garden. By the 1890s, this was seen as the town's premier location, with the more exclusive of Brighton's two piers, the West Pier, in plain sight. For a location that has seen so much life, happiness and celebration, its story starts off surprisingly with a death.

Frederick Gordon had been a London solicitor. Following the death of his wife, he diverted his energies into creating one of Britain's first hotel chains, and so after the construction of the Monte Carlo, Cannes and London Metropoles, Frederick Gordon Hotels Ltd opened their fourth Hotel Metropole and fifth hotel in Brighton on 26 July 1890.

Costing £57,000 and built by Thomas Holloway, the hotel had over 700 rooms and seated 500 diners simultaneously. It was the largest and most prestigious in Brighton as well as the nation's largest hotel outside the capital. Royalty, the aristocracy, and the internationally rich and famous would all become an ongoing feature, willing to pay from £3 8s a day for the luxurious suites on offer that offered hot and cold tap and seawater to guests.

The hotel's opening day caused such excitement that special luxury trains had to be chartered from London Victoria for the 1,500 extra visitors. King's Road turned red as a special red carpet of Hassocks sand graced the road to meet the VIPs that would climb

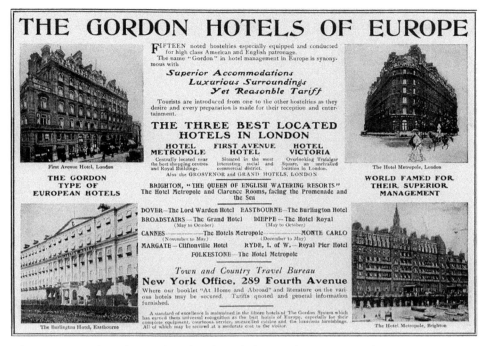

Above: A 1907 advert for Gordon's hotels, including Brighton's Metropole.

Below: The Metropole's heated main staircase in 1890.

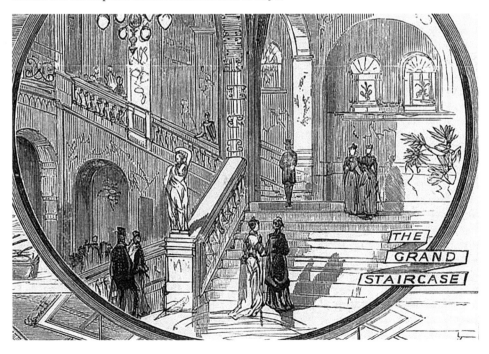

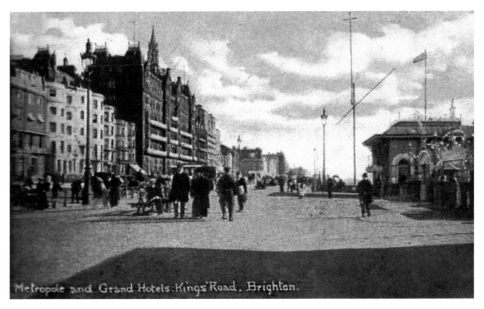

Above: The Metropole and neighbours facing the King's Road in the hotel's early days. Esther and Gorse would have crossed over from the West Pier to the Metropole for cocktails in Patrick Hamilton's 1922 novel.

Below: The Metropole today. Waterhouse's waterside wonder is not a listed building, despite being the only large coastal public building and hotel Alfred Waterhouse ever designed.

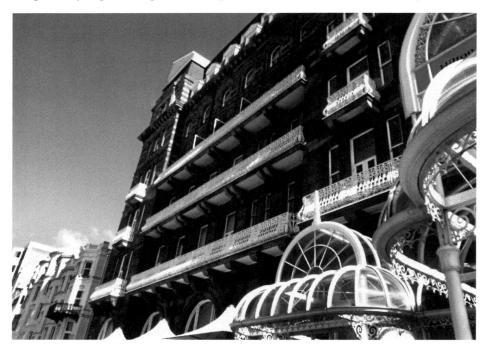

the entrance steps. Rumours flew around the town, including that the hotel sported over 4,000 bedrooms, the Turkish baths could accommodate a thousand bathers simultaneously and that there were enough electric lights inside to light every house in Brighton! The electric lifts were also a celebrated feature and not only was the drawing room heated by a fireplace carved by Queen Victoria's nephew, but the staircase was heated too. Fears of any danger from these technical developments were assuaged by the guarantee that the hotel was fireproof.

All the senses were to embark on a journey of pleasure on opening day, from the opulence of Tottenham Court Road furniture firm Maple's furniture, to three public baths, to reading the latest literature, experiencing spiritual moments in the hotel chapel or listening to either the hotel's own band, or the Coldstream Guards in the dining rooms. Those concerned about noise from the sea could face the calm of the beautiful Italian Gardens, Clarence Rooms or later the Winter Gardens. Despite predictions that hotels as magnificent as the Metropole would never be viable, or that existing hotels would be hit by its opening, the *Brighton and Hove Gazette* was correct in its prediction that there was 'plenty of room for as new and elegant [a] hotel as the Metropole'. The hotel's opening day was the beginning of a golden era for Brighton hotels that would last until the late 1930s.

The Metropole was the famous architect Alfred Waterhouse's forty-first project and his second in Brighton and Hove, his first being Hove's Town Hall that burned down in 1966 and his third a block of offices and shops in North Street, demolished in 1970. Its architectural style was claimed to be unusual for Brighton, but not for Waterhouse, with the Metropole sharing many features with his earliest hotel, Liverpool's North Western, or even Gordon hotels, who used a similar style with their Russell Hotel in London. The Metropole was not, however, the first red-brick building in Brighton; an earlier one, the Chapel Royal, dates from the late 1700s. The Victoria was also an earlier red-brick and terracotta hotel, currently the Umi, which was painted white in the late 1970s. However, when building commenced in November 1888, the Metropole's use of red brick and terracotta on the seafront was unique for a building of its size and position. The building attracted critics but also warm praise: 'A magnificent place!' said the editor of the *Brighton & Hove Gazette*, who also predicted it could 'withstand any accident', due to the strength of its construction. *British Architecture* felt it 'a wonderful relief to come across the hotel with its warm colour, picturesque skyline and variety of light and shade.' The *Builder* magazine simply said: 'Sumptuous!'

The original skyline was demolished in 1961 after the roof timbers were found to be unsafe, but the colour, light and shade have mellowed gently over the years and Waterhouse's choice of building materials was justified. Seafront locations have ensured much restoration for Brighton's traditional whitewashed stucco-fronted architecture, but the Metropole's high Victorian frontage has gently faded, becoming much loved and remaining in good physical shape. Use of red brick and terracotta caught on locally, with villas in Hove, the Municipal Technical College on Lewes Road and the wonderful clock tower in Preston Park all using these materials to great effect. Over the years, the hotel has moved physically closer to its older rival, the Grand, as both have developed towards Cannon Place; it has also replaced its mansard roofline, built flats above the rear building and constructed arguably, Brighton's first 'i270', the Starlit Lounge. The Italian and Winter Gardens have all been developed but the hotel became instead the home of Brighton's first purpose-built exhibition halls, which helped to save Brighton as a resort; holidaymakers were replaced by delegates and exhibitors in the 1960s. The hotel has become wider, taller,

deeper and larger, and is now a residential conference and exhibition centre that still employs over 300 people, as many as it did when it first opened. The grand Victorian heart of this wonderful building still beats in the Clarence Suite towards the rear of the complex and in the still recognisable Waterhouse frontage, even with the post-war alterations. Ashamedly, the last remaining Waterhouse building in the city and Waterhouse's only seafront public building or hotel has never been listed.

The Hotel Metropole has been the first to achieve, celebrate or experience a number of things throughout its thirteen decades, some inspirational, some unusual, some amusing, but all interesting. The hotel has had many links with transport that give it a series of firsts. Not only did Brighton's first visit by a motor car end up at the Metropole in 1896, but the London to Brighton car race, which still runs today, originally ended outside the hotel's doors and its first run was followed by a celebration dinner at the hotel. The race was created to celebrate the emancipation of the Motor Car Act 1903 – the repeal of the law insisting motor cars required a man with a red flag running in front of the car.

Just how exclusive the nature of the Metropole's dining and drinking experience is revealed best in Patrick Hamilton's 1922 novel *The West Pier*, when the heroine, Esther Downes, ponders which one of her two wealthy suitors, Gorse and Ryan, will be well dressed enough to be allowed in to the hotel to buy her cocktails. Twelve years later, the experiences of Stan Vomberg were also illuminating as to the level of service. 'There were 24 waiters, no women,' he revealed in 1981, 'the waiters all wore frock coats, with white gloves on special occasions.' Winston Churchill's stay in 1947 to receive the freedom of the town also led to a certain level of service; he requested that his porridge be made only from the cream at the top of the milk. By the 1950s, however, the hotel was not only losing money, but its food was 'terrible' according to Harold Poster, whose AVP Group bought the hotel from Gordon Hotels. Children today would agree – menus from the hotel contained dishes out of fashion today, such as 'ox tongue'. With his 1960s hotel redevelopment and expansion, Poster soon increased not only the number of kitchens and amount of food consumed, but also the different types and the amount of praise the hotel's food received. Not only did the exhibition halls provide new eating venues but they had to provide high-quality food for more mouths than any other Brighton hotel. Rather than 500 diners, as in 1890, it could now be 5,000. The hard work paid off. In 1964, the hotel's Starlit Restaurant gained a feature in the coveted Egon Ronay Guide and the highest rating in the town. This was reflected in how popular it was: Poster expected it to take £40,000 in its first year, it took £70,000 instead.

The Metropole has provided literary refreshment as well as refreshment of the edible kind. It has always had a passion for the literary and cultural, boasting a library or writing room since its opening day. Even the hotel's official scent on its opening day, 'The Light of Asia', had a literary feel, the name being suggested by the poet Sir Edwin Arnold after his best-known work. It was also designed to reflect the 'oriental' theme running throughout parts of the hotel from the Turkish baths upwards. The Drawing Room's decor was also inspired by travel literature, with its Arabian ceiling reflecting a famous travelogue of the time, *Travels in Arabia Deserta* by Charles Doughton. It has also been visited with a large number of high profile literary guests and it now seems Graham Greene wrote some of *Brighton Rock* while staying at the hotel. Oscar Wilde visited the Metropole from 4–7 July 1894 with Lord Alfred Douglas, after leaving nearby Worthing where he wrote his most famous play, *The Importance of Being Earnest*. Lord Alfred, better known as 'Bosie' may also have visited the hotel earlier on in his life when his father, the Marquess

of Queensberry, was known to frequent the hotel to enjoy cigars. Bosie lived in the town when young and returned to it in old age. Charles Dickens' son, also named Charles, stayed at the hotel in 1891 to rest after a series of lectures. The Metropole's greatest literary fame however can be said to be its mention in T. S. Elliot's ground-breaking 1922 poem, *The Wasteland*. Like the Metropole's early days, its mention was seen as modern and a little shocking. Other 1920s literary mentions include Esther, the aforementioned heroine of Patrick Hamilton's book, *The West Pier*, who is treated to cocktails at the Metropole. Graham Greene, himself no stranger to literary recreations of the town, called it, 'the best book written about Brighton'. The hotel's most recent literary mention was in the sixth Roy Grace novel, by internationally famous local novelist Peter James, who started off *Dead Like You* with the Metropole's New Year's Eve Ball. His most recent novel, *Love You Dead*, also mentioned the 'Met' as a luxury hotel.

The Hotel Metropole has not just had literary greats, but also many rich, illustrious, famous and regal visitors through its revolving front doors. It has had at least eight British Prime Ministers and one Russian, two Deputy Prime Ministers, numerous ambassadors, a marquess, dukes and duchesses, two kings-to-be and at least sixteen royals. The hotel today is just as likely to welcome the Kaiser Chiefs as it was Kaisers in the 1890s and has been the haunt of celebrities including the late Jill Dando, Derek Nimmo and Barry Manilow. Famous ladies include Shirley Bassey, Lily Langtry and Clementine Churchill. Opening week in 1890 saw visits from the Countess of Stradbrooke, Lady Gwendoline Rous, the Hon. Charles Willoughby, Sir Jasper Carmichael, the Comtesse du Bremont and the sublimely named Count Apponyi. As the hotel's fame and reputation grew, the names of its elite inhabitants seemed to become equally more exotic, with the Indian prince the Maharajah of Cooch Behar in September 1900, soon followed by the Gaekwar of Baroda in November, accompanied by his wife, the Maharani and their five children (four princes and one princess). 1900 also saw Prince Antonie d'Orleans, the Infanta of Spain, Princess Alexis Dolgourouki and a Prince Ibrahim.

Britain's most famous leader to grace the hotel must of course be Sir Winston Churchill, who stayed for two nights and dined in the Library in 1947. A card given to Mr Patrick Price from the hotel staff who looked after him is still there today in the room named after his visit. Leaders of Hollywood and not Westminster were gracing its rooms decades later in 1970 and happy to enjoy the 'Metropole experience', no matter what: Richard Burton and Elizabeth Taylor were happy to stay in a modest £16.05 per day room. This was as all the most exclusive rooms were booked for conferences. However, being Hollywood stars they did book four of them!

The Metropole has been in existence through bad times as well as good. The First World War had less impact on the hotel than that of the Second World War. With few wartime restrictions on where British civilians could go in the First World War, Brighton was busier than ever, with foreign holidays less likely due to the war across the Channel. This meant the Metropole, like many of Brighton's hotels, was full, despite rationing by the end of the war. Unfortunately, not all of those associated with the hotel were unaffected. The staff of many in the hospitality industry tended to be Austro-Hungarian or German and so faced dismissal, internment or deportation under the British Nationality and Status of Aliens Act 1914. Hotels advertised proudly their compliance with this rule. The Metropole's one-time head waiter, who, according to obituaries, had been an employee of the hotel for two decades in 1914 was a Mr Frederick Wesche, who had lived in Britain for thirty years. Despite three of his sons going off to fight against Germany, he was one of 400 German or

Austrian-born Brightonians given forty-eight hours by the authorities to move away from the coast or leave the country or face internment. He opted for the latter and moved to the USA, his family eventually settling in Canada where his descendants still are today.

Horses and millionaires linked with the hotel were also affected by the First World War. Forty horses were used by the American millionaire, Alfred Gwynn Vanderbilt, in his famous resurrection of horse-drawn travel to London for the rich and famous that commenced at the Metropole. Thirty of the horses were requisitioned for service in the war and Vanderbilt was said to be devastated, as he knew all the horses' temperaments well. He then supported the supply of ambulances to the Western Front and was drowned on 7 May 1915 on board the *Lusitania* after giving his life jacket to save a female passenger, Miss Annie Middleton, who was one of the few survivors.

Like its neighbour the West Pier, the Metropole enjoyed a second golden age in the interwar era, but was closed in 1939 for the duration of the Second World War. The beach was soon off-limits to the public as anti-invasion preparations were made. Gordon Hotels, who were still the owners at the time, were given three weeks to vacate the property and to store its furniture and fittings, some of which were stolen during the war. The famous front door that so many rich and famous had entered was locked and a 'closed' sign hung forlornly from it. Instead of the rich and famous passing beneath it, the glass portico at the hotel entrance now protected a tramp called Feathers who adopted it as his home. The following year, the War Office requisitioned the Metropole and forty-one other hotels as part of 'RAF Brighton': it would house the administrative air force staff from the RAF from 1941 for training and housing, and then from 1943 the New Zealand, Polish and Australian Air Forces. Altogether 60,000 air force personnel went through the hotel's doors and, according to ex-WAAF Lilian Rogers, it was a happy place, with personnel very fond of the 'Grand Old Lady'. One of the air force personnel clearly enjoyed their time a bit too much as Lilian recalled that someone famously got onto the rooftop and hung something risqué from the flagpole! The suspect and article in question both remain a mystery to this day.

The hotel had a more sinister brush with air forces however. The hotel escaped the bomb damage to other parts of Brighton but in 1943, the town was attacked by Focke-Wulf fighter-bombers. The Metropole's rooftop machine gunner fired at one as it passed by and the aircraft returned fire at the gunner and the building. The nearest the enemy got to the hotel after that was its role in 1945 as a POW repatriation centre. Therefore a burst of machine-gun fire was, thankfully, the closest brush with danger the hotel received from enemy action. As a Red Cross Centre in April 1945, it even helped those affected by enemy action. However, when the War Office returned the hotel to Gordon Hotels in 1946, the years of neglect, its busy war role and the advancing years of the building meant it desperately needed rewiring and redecoration; the latter was carried out by Ashley Horner of London. The building needed further refurbishment, but would have to wait until new ownership in 1959 for that.

As the 1960s loomed, the hotel was outdated, needing rejuvenation and experiencing the 'seventy-year-itch' that plagued many of Brighton's hotels. Gordon's were losing £10,000 a year on the hotel and apparently looking to either demolish the building or change all but the bottom two floors into flats. It seemed that the days of large, prestigious hotels were over. Resorts like Brighton were doomed, replaced by the start of cheaper, overseas package holidays. The hotel's once-illustrious Italian and Winter Gardens lost their romantic appeal as encroaching tower blocks sprang up over the town.

Thankfully, one man believed large hotels could survive. 'Nothing but the best is good enough for Brighton,' said the Metropole's new owner, Harold Poster, CEO of Associated

Veneers and Plastics (AVP). The Metropole became the jewel in the crown of his industrial and commercial empire, so much so that he built most of the modern hotels bearing the name of his 'favourite'. Poster ensured not only did it remain a hotel, but *the* hotel to be seen in once again if you were rulers or royalty. It had always been Brighton's biggest hotel (the biggest outside of London), but it was now to be even bigger. The hotel embraced the consumer needs of the twentieth century and became Brighton's first residential conference and exhibition centre over a decade before the Brighton Centre was built. The unsafe roof timbers were replaced with the country's first rooftop restaurant, the Starlit in 1961. Its grounds included Britain's first European-style licensed casino from 1962 and by the late 1970s it boasted 100,000 square feet of conference and exhibition space. Political parties finally had a Brighton venue befitting party conferences.

Since AVP's purchase of the hotel, it has changed hands a number of times, right up to the present owners, the Hilton Group. They are rightly proud of the unique Victorian survivor they purchased, along with its architecture and heritage. The Metropole deserves far more than just being somewhere Brightonians and visitors to our city take for granted. It tells the tale of Brighton from its late-Victorian grandeur of the resort's heyday. The hotel was called brash, loud and shocking – but these are all descriptions of Brighton. Hotels have to stand out to be noticed and the Metropole certainly did, and its uniqueness means it still does. Waterhouse never built another public building, let alone a hotel on any seafront, so it really is unique. That uniqueness deserves protecting and Waterhouse's waterside wonder should be listed now.

21. Hotel du Vin/Bar du Vin/New Ship Inn

People often think the Old Ship Hotel on King's Road was named after an actual old ship, but it originally was just The Ship, with Ship Street named after it. It was never where it is now, but had its entrance in Ship Street instead and until 1790 faced another inn and hotel. The building that is now the Hotel du Vin was once a newer hotel than The Ship and faced the original entrance. The fact that they were both once called The Ship led to the older Ship taking the name The Old Ship, whereas the 'new' ship has gone through many regenerations, including a spell as Henekey's Night Club but now is an exclusive hotel. Like the King and Queen pub, it has confused numerous visitors who didn't look too closely. Both the Hotel du Vin on Ship Street and the King and Queen in Marlborough Place replaced older buildings in the 1930s. They were both built in a style called 'Brewer's Tudor' by brewing group Edlins, who spent a fortune recreating a retro style. The Hotel du Vin is also a history nerd's paradise, featuring a medieval portcullis. It also has a date on it that is incorrect for even the original New Ship. It may be an historical recreation, but like the King and Queen it showcases a unique architectural design from an interesting era and the building has many clues as to its older versions.

22. Brighton Harbour Hotel (Previously the Hotel Umi/Belgrave/Victoria Hotel/Orleans Residential Club

Brighton Harbour Hotel, as it has just been renamed, has an unusual history and also an unusually long chain of different names (like many Brighton hotels). Starting as the

Above: The Brighton Harbour Hotel during its time as the Hotel Umi, older than and originally the same colour as the Metropole.

Below: The Brighton Harbour Hotel when it was known as the Victoria Hotel. (Courtesy of Royal Pavilion and Museum, Brighton & Hove)

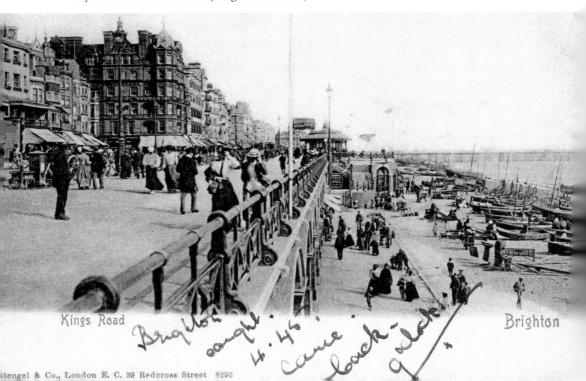

Kings Road

Brighton

tengel & Co., London E. C. 39 Redcross Street 8290

fashionable Orleans residential club, it was actually the first red-brick and terracotta building on the seafront, eight years before the Metropole, which most people believe was the first. The building was later whitewashed and remains that colour today. It was first renamed in 1898 as the Victoria Hotel and has also been the Belgrave Hotel before becoming the Hotel Umi in recent years, which was aimed at an upmarket backpackers' crowd. Criminally, it once face a similar-looking inn and hotel building on the southern corner of West Street, since replaced by the horrific Kingswest building. However, the Brighton Harbour is still a beautiful Victorian six-storey building and with a new exclusive bar and restaurant on the ground floor, it looks set for a more upmarket future.

23. British Airways i360

Brighton has a tradition of exciting, technological, controversial, world-famous and game-changing buildings, and the British Airways i360 is no exception. Since its first flight in 2016, at 162 metres (the pod rises to nearly 140 metres) it is now the country's tallest observation tower outside of London and also the world's first vertical cable car, with the city's first moving 360-degree view, hence its name. It is also vital in helping continue the regeneration of this part of West Brighton, envisaged to bring in 700,000 visitors a year to an area of the city that was neglected in the 1980s and 1990s as development centred

The British Airways i360 – the most recent in an exciting range of engineering firsts in Brighton.

around the Palace Pier. One of its aims is that it will eventually help create a new West Pier as well as taking Brightonians and visitors for a ride on the 'pier in the sky'. There's an awful lot to like and Brightonians who aren't sure about our latest piece of engineering excellence should take heart that Regency Square residents back in 1866 weren't sure about the West Pier either. Firstly, it will be unique to Brighton. Secondly, as you'd expect for a city of environmentalists with a Green MP, it will only use 'green' energy; amazingly, the i360 pod's descent will generate half of the electricity needed to power its ascent. Thirdly, £25 million should be injected into the local economy, with £1 million at least being paid to Brighton Council every year. Fourthly, any visitors in every pod journey (up to 200 people) will be seeing parts of Brighton they'll hopefully want to visit – it's Google Maps with an exciting journey thrown in. Fifthly, 440 permanent jobs will be created – 169 at the attraction, the rest from related benefits to the city. Also, there is nothing exactly like it anywhere in the world – it is the slimmest tall tower in the world. The pod will have a champagne bar. Best of all though, local school children each get a free flight and residents will all see an exciting new view of the city.

It seemed inevitable that Brighton would get a tall building of this type. Fifty years ago, plans were made for a 'Skydeck', which would have been based not far from the site of the current i360 on its own pier, but would have had an internal lift rather to the observation deck, rather than a moving observation pod. Back in 2002, Brighton College headteacher and historian Anthony Selden also envisaged a Brighton with a tall observation tower, again in the West Brighton area in his book *Brave New City*. The i360 has been a hugely complex engineering task, but with the architects of the London Eye, David Marks and Julia Barfield, behind the design, the i360 is, in all ways, a building that has risen to the challenge. Brighton is, and is looking up in more ways than one.

24. Jubilee Clock Tower

Built between two slum areas, Durham and Petty France, at the top of West Street in 1888, the year after Queen Victoria's Golden Jubilee (thankfully its timekeeping has been more punctual than its opening date!), the Jubilee Clock Tower is known as *the* clock tower in a city of a surprisingly large number of clock towers. It has had a chequered history, and like the Town Hall, was expected to be pulled down for many years. Its detractors started complaining about it early in its life when its timeball, a golden orb that climbed slowly up a mast and then sank down on the hour, was criticised for causing a whistling noise. Despite the fact that this engineering marvel was designed by Brighton genius Magnus Volk, and was soon copied by the chemists at the bottom of Cannon Place where the Salt Rooms are now, it was decommissioned. As motor traffic cluttered up the Victorian streets that had been designed for horse and carts, it became the centre of an unloved traffic island and was blamed for the congestion. Even legendary architectural critic Nicholas Pevsner called it 'worthless' in 1965. However, the mood has changed and Brightonians now cannot imagine their city without what is effectively its Victorian time-telling heart. Victoria may not have liked Brighton, but its people love the symbol of their ancestors' devotion to her and later editions of Pevsner's guide now admit that its founder's view was a bit harsh to say the least. The Clock Tower is now part of the landscaped area around by the Quadrant and firmly part of the city, no longer a tower with a toilet as it was once merely seen as. How

The Jubilee Clock Tower, complete with added Magnus Volk timeball.

can anyone not love an ex-toilet covered with pictures of royalty, with a piece of Volk's engineering at the top and boats pointing the way to different destinations? It is a Swiss army knife of a building. In the children's novel *Chronophobia* by Thomas Stakeman, set in Brighton in 1997, it is one of the timeportals of the Chronomen, a set of humans able to 'play' with time and defeat an evil force set on destroying humankind. This which certainly makes you look at it differently, but most of all, it deserves to be the centre of all future New Year's Eve celebrations in Brighton: our very own Times Square .

25. King & Queen Pub

The King & Queen on Marlborough Place was once a farmhouse, before being transformed into a pub in 1779. It is worth a visit as its once isolated location north of the old town make it one of the first developments outside of early Brighton. It is a Grade II listed building that even had Margaret Thatcher turn up unannounced during the 1982 Conservative Party conference for a revue evening! Luckily, it wasn't during one of the 'Miss Miniskirt' competitions the pub also used to hold at that time or she might have been less than approving. Another visitor the Iron Lady might not have approved of was Fat Boy Slim, who also played there once.

Like the Hotel du Vin on Ship Street, the King & Queen in Marlborough Place replaced older buildings only back in the 1930s. Also in 'Brewer's Tudor', the King & Queen has a Tudor-style fireplace and minstrel's galleries but also provides some wonderful mistakes to spot for history lovers! Despite being named after the Hanoverian George III and his

The King & Queen in earlier guise.

queen, Charlotte, it has images and references to the Tudor Henry VIII and his second wife Anne Boleyn, as well as medieval windows and banqueting hall, created in 1967. Not somewhere to take a history purist! It was the earliest Brighton pub on record to experiment with barbeques and embraced world beers years before the current trend. The upstairs bar, 'Prinny's Bar' claims to have sold 'beers of the world' back in the 1980s, again adding to the mishmash of historical eras this pub tries to cover. It is surprising it has never embraced its military connections, as in the days when a military garrison was encamped behind the pub to protect royalty in residence, the soldiers would be served through a serving hatch.

26. King's House (British Gas HQ/Princes Hotel)

Brighton & Hove Council are the inhabitants (for the moment as it is due to be sold off) of an intriguing building. King's House (as it is currently called) has had a number of uses, but, like Embassy Court, it is more of interest as a sample of a far larger planned development. Both were 'showhouses' in a sense. It is the only building built of the huge planned estate by the Stanford family, owners of the manor of Preston which stretched this far west into Hove. It started life as the Prince's Hotel, which proudly boasted to be in Brighton (although technically in Hove) and also boasted in the First World War how it patriotically refused to employ Austrian or German employees. It was also home to British Gas offices before its current role with the council, as Brighton Town Hall couldn't possibly house all the departments of a local government the size of Brighton and Hove.

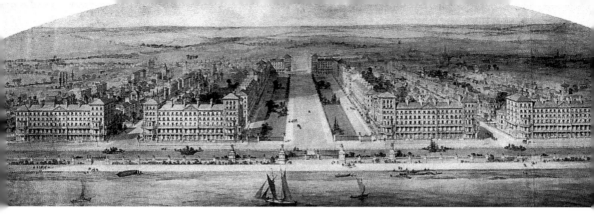

Above: The planned estate to be built to rival Kemp Town and Brunswick, on land owned by the Stanford family; only the Princes Hotel (centre left block) was ever built. (Courtesy of Royal Pavilion and Museum, Brighton & Hove)

Right: The Princes Hotel – note the anti-foreigner focus.

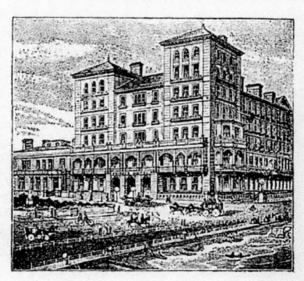

PRINCES HOTEL

BRIGHTON——Grand Avenue, HOVE

The finest position in Brighton

AN ENGLISH HOUSE OF THE FIRST ORDER

An English owned Hotel, without German or Austrian employees
Unique position overlooking the sea and famous Hove Lawns

Magnificent self-contained suites of apartments, with balconies and verandahs facing South and West. Handsome Lounge and Conservatory

THE CUISINE IS NOW UNDER THE DIRECTION OF A RENOWNED CH

A CHOICE STOCK OF FINE VINTAGE WINES HAS RECENTLY BEEN PURCHASED

Passenger Lifts to all Floors Excellent Golf Links. Ten
Sea Water Baths. Motor and Croquet Lawns, &c. M
————Garage and Pit———— Modern Sanitary Arrangeme

THE DINING ROOM IS OPEN TO NON-RESIDENTS
FOR MEALS TABLE D'HOTE OR A LA CARTE

*Hotel Omnibus to
and from Station*

Telephone : Hove 2484
Telegrams : " Princes Hotel, Brighto

27. Kingswest/Top Rank Suite

Originally called the Top Rank Suite, being owned by the Rank Organisation, owners of the Odeon chain and film producers for many years, the Kingswest/Kingswest Boulevard is a building that is definitely well used, but not necessarily well liked, with its detractors calling from its demolition from the time of its construction in the 1960s. There had always been plans to build down from Western Road to the sea, and clearances started in the 1930s. By the 1950s plans were afoot to have a huge development, complete with five tower blocks, of which only one was ever built. At one point, even the Grand was due to be demolished as part of the scheme, but the building of the Kingswest meant that beautiful and architecturally valuable buildings such as the George Inn on the corner of the West Street and King's Road were actually lost. As you can see from the 1959 plan, an earlier version of the Kingswest was planned even then, but with a much more useful rooftop, providing dining facilities that acknowledged that the building was actually by the sea. The 1965 building that this plan evolved into not only lost its rooftop but gained a spiky gold

1959 plans to develop the seafront and build the first attempt at Churchill Square. Only some of this was built, including a scaled-down version of the Kingswest Boulevard.

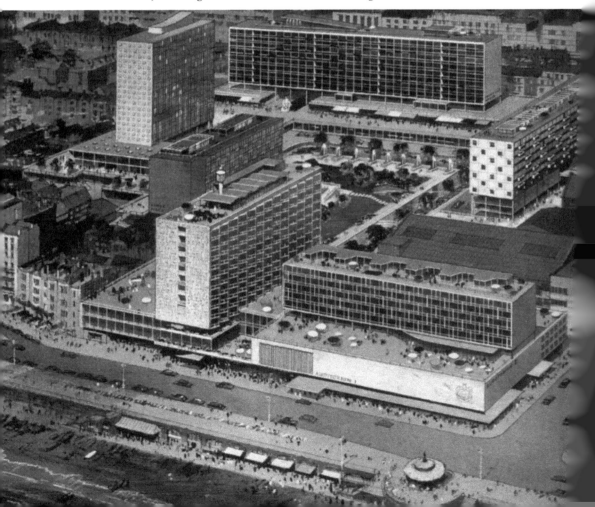

roofline, designed to look as if it was floating above the glass level beneath it. In practice it never worked. What mattered more was that not only was it insensitive to its surroundings, but appeared to be that most pointless of edifices: a prime seaside building that didn't want to look at the sea. Its transformation from the Top Rank Suite, a ballroom and conference facility, to the Kingswest Boulevard only made critics more vociferous. It was now an underground club, bar and cinema, two of which were buildings that specifically didn't want windows. The sheer face of soulless and featureless concrete drew complaints, and the public didn't warm to it as they had done to other game-changing seafront buildings like the Metropole. Demolition seems to finally beckon with envisaged developments at Black Rock, but this building deserves a mention as an example of how an unpopular building has survived for half a century despite being detested. Its main importance is that when it stopped providing conference facilities the less architecturally offensive but more significant Brighton Centre was built to take over. In its defence, it has kept over three decades-worth of cinema-goers entertained, clubbers clubbing and is the only building in Brighton that takes its name from a merger of the two streets it is in.

28. Brighton Marina

The Marina was 'Brighton's Cote d'Azur – only nearer' as it was marketed in the 1970s. With a tradition as a cross-channel port, it was evident that there was the demand for a place in Brighton for boats to dock and passengers to embark and disembark from. The Chain Pier was built for this purpose, not for entertainment as piers are today, and numerous schemes involving a man-made harbour were proposed over the years. Kemp Town had a temporary harbour when the estate was being built in the 1820s but by the 1960s, local businessman Henry Cohen was the driving force pushing for a new marina,

One of the massive cranes at work building the Marina's outer wall between 1971 and 1976.

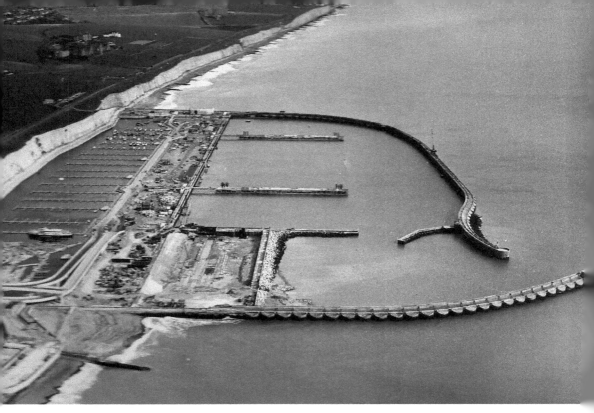

The near-finished but unprofitable Marina.

first nearer Kemp Town, but then in its eventual position in Black Rock. Its idea was simple: provide a home for the boats of those who want a large, exciting city next to where they berth. The south coast had a shortage of places for the increasing number of boats at this time. We forget just what a huge engineering undertaking it was – we have the largest marina in Britain, and before the building of the Channel Tunnel, it was one of Britain's most ambitious building projects, along with the Thames Barrier. 1,850 metres of concrete walls now project into the sea, meaning 126 acres of what was once the sea is now controlled by humans. The harbour walls are made of concrete cassons, huge concrete 'drums' each weighing 600 tonnes, which were put in place by the country's biggest cranes at the rate of one every nine days and filled with 1,200 tonnes of sand between 1971 and 1976. Several men died building this voluminous venture.

The marina provides thousands of jobs for the city, has ensured that many can now keep their boats on the south coast, and is a permanent home for Brighton's fishing fleet. However, at first it was not the success it is now, and cost £41 million just in getting permission for the entrance, even after permission was granted for the marina itself. The marina started life with many more berths than it has now, but was half-filled in so that the actual 'marina' part is now much reduced, as the picture of the marina in its early days shows. Several owners later, it now is a thriving and busy microcosm of Brighton to the east of the city, with its own shops, homes, restaurants, entertainments, gym, hotel and is soon to have a further development completed. Black Rock is soon to capture this boom area with its planned conference zone, which is intriguing as the marina's earliest plans were for it to have its own conference centre back in the 1960s.

29. Madeira Terrace

A unique building feature of Brighton between the Colonnade at the Sea Life Centre and the Concorde 2 club is Brighton's rusting but amazing mile-long Madeira Terrace. It shares a similar problem to the West Pier, Palace Pier and even the Royal Pavilion in that its construction using now-elderly metal needs constant repair. (The Pavilion has an internal frame of metal and metal inside its elaborate stonework – this was very advanced for its age but is now problematic.) Hopefully the council's recently published plans to restore it will be successful as we cannot let it become another West Pier debacle, with years of stalling and debating rather than restoration work. Built between 1895 and 1898 in Madeira Terrace (originally Madeira Road), the Terrace is unique to Brighton and appears in numerous Brighton adverts and images. Strolling underneath the terrace is a wonderful walk along the chalk east cliffs of Brighton, permanently preserved in concrete. Above, where you still can, the walk is even better. The walk highlights the beauty of Brighton but also showcases an incredible example of yet more nineteenth-century engineering mastery with metal. It also has a number of staircases that allow you to walk above the terrace and stand where thousands have in the past, watching motor races or even the Radio 1 Roadshow in its days of visiting Brighton. Even though parts of it have been closed for safety reasons, only in Brighton can you walk along a metal wonderland and see just how far south Brightonians have reclaimed the land over these waves. Madeira Terrace is therefore really our third Victorian pier. It travels across where the sea once was – just along the cliffs, not out from them.

Madeira Terrace in the early twentieth century. Almost a pier, and today in trouble.

EIRA WALK

30. Marlborough House

Marlborough House is nearly as important as the Pavilion, perhaps more so. Largely ignored these days on the Steine, it was first built in 1765, is one of Brighton's oldest houses from its early days as a resort and is the oldest surviving house on the Steine. The Steine was then the most fashionable address in Brighton and desirable properties faced inwards to watch the well-to-do promenade around its gardens. Back then, a sea view was not as desirable in Brighton as it would later become. Moreover, it was rebuilt for the Duke of Marlborough who, along with the Duke of Cumberland, was responsible for bringing Prince George (as George IV was then) to Brighton in 1783. George also stayed there twice, inspiring him to want his own residence. If the dukes hadn't graced Brighton, other nobles and wealthy folk wouldn't have followed. And no George means no Pavilion!

The Duke of Marlborough was also vital in shaping the Steine – diverting the Wellesbourne underground and rebuilding Poole Valley – and therefore it's the home of one of the 'architects of the Steine'. It is also the earliest house in Brighton built specifically for visitors, originally constructed by Samuel Shergold, another crucial figure who also owned the Castle Inn (Brighton's first purpose-built major hotel and assembly room for its first visitors). Additionally, although it was rebuilt in 1771 (it was originally red-brick) for the duke it is architecturally recognised as the best building in Brighton, built by the best architect of the day, Robert Adam. Its design is unique to Brighton and shows what Richard Russell's (the doctor who encouraged the aristocracy to come to Brighton for health) house looked like. Finally, at one point William Hamilton, who bought the house off the duke,

Marlborough House. Forgotten about of late but as important as the Pavilion in many ways.

Marlborough House in its early days. (Courtesy of Royal Pavilion and Museum, Brighton & Hove)

was even competing with the prince to see who had the better house. There are not many houses that still exist today that can claim they tried to compete with the Royal Pavilion.

31. Mercure Seafront Brighton/The Norfolk Hotel

Built between 1864 and 1866, and opening in a similar era as the Grand, this smaller Victorian treasure is a Grade II listed building, which started its life as an inn – the Norfolk. Its Grade II listing is partly due to some original features such as mirrors, a staircase and the gates to its original 'ascending omnibus' (lift) still existing and its fantastic example of mid-Victorian design. It was described soon after opening as 'more beautiful than any other building in Brighton' by *Moorcroft's Guide* of 1866. This was praise indeed with the much-more imposing Grand Hotel was not too far away. The Norfolk Hotel took its name from the inn that was on the same site, which was completely demolished. The name presumably came from the town's links with, and patronage by, the Duke of Norfolk at that time, who also enjoyed homages to him in other parts of the town and even in the toll bridge at Shoreham.

By the 1960s the Norfolk Hotel was owned by Harold Poster's AVP hotels group, but was sold off in 1969 when Poster was denied permission to demolish it and turn it into a block of flats. In an opposite move to the Metropole and Grand, who built nightclubs in their basements, the Norfolk boasted a rooftop nightclub at one point called Rafters. In 1985 it also managed to become the first hotel in Brighton to have its own swimming pool, winning a much-publicised competition by the town's hotels to be the first to have bathing residents. It even matched the building of an indoor water feature with an external one by also building an ornamental lake in its grounds. The Norfolk managed to keep its name from its earliest days until 1971, when it became first the Norfolk Resort Hotel, then the Ramada Jarvis Hotel Brighton (another mouthful of a hotel name!) and now the Mercure Brighton Seafront Hotel, part of the Jupiter Hotels Group. Like other Brighton hotels it has faced many changes but it remains a beautiful piece of seafront architecture; like the Grand and the Metropole, it is a 'show hotel', and a one-time playground of the rich and powerful that stimulates your imagination when you enter its doors.

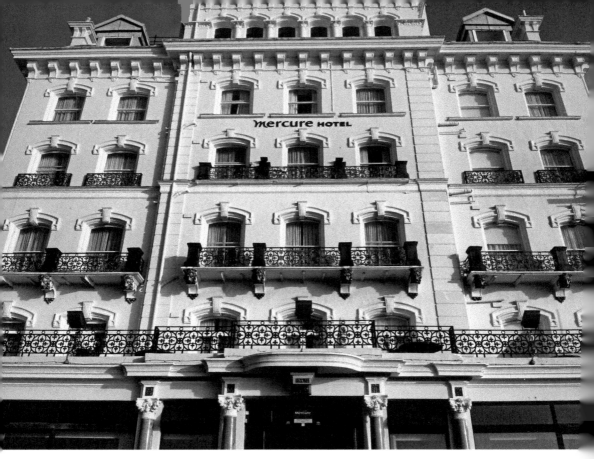

The Mercure Seafront Hotel – smaller, but just as majestic as the Grand.

32. Old Ship Hotel

The Old Ship boasts the label of Brighton's oldest hotel, and has played a major role in Brighton's history. However, the building has been somewhat of a chameleon, starting life as a private home in the 1500s before becoming the Ship Tavern in Ship Street in the 1500s. Ship Street in the Lanes takes its name from the building, quite aptly as its main entrance graced that street, not the seafront, which it didn't expand into until 1794. Since then it has enjoyed its current location both in Ship Street and on the seafront.

While still solely in Ship Street, it was purchased by Nicholas Tattersall, the ship owner who had taken on the voyage of sailing the fugitive Charles Stuart from Shoreham to France during the Civil War. Tattersall's fee from Charles II (as he became) and subsequent pension meant that in 1671 he could buy an old tavern and since then the hotel has continued to expand and improve. It has been a courthouse and even a post office. Also, before the town hall existed, the building hosted many important town meetings, was a coaching inn and has even hosted an auction house. It was also where the idea of a veteran car club (which became annual Veteran Car Run) was first mooted. A century later, it was also the location where, as early as 1996, it was the first hotel to give all its guests internet access and their own email account.

Above: The Old Ship today – the seafront side of the hotel are later additions to a once west-facing small inn in Ship Street.

Below: The Old Ship in the 1800s when the sea was slightly closer.

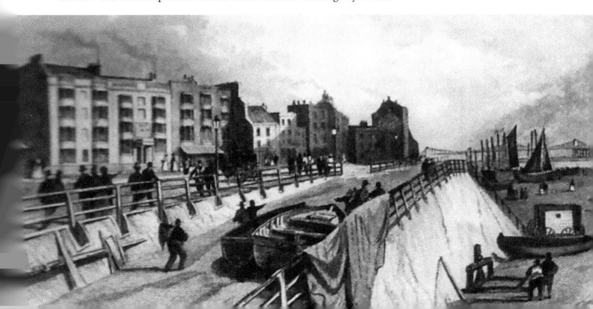

It is named the 'Old' Ship not after the boat owned by Tattersell (which was called the *Surprise* and later renamed the *Royal Escape*), but as another tavern named 'The Ship' opened across from it in Ship Street and it needed to distinguish itself from this 'New' Ship (on the site of the Hotel du Vin today). Tattersall's financial gains from his service to the restored king meant that Old Ship enjoyed investment and expansion, something it has continued to enjoy into the twentieth century. Some of the timbers from the *Surprise* are even said to be part of the beams of the cellar. The navy obviously cherished the boat before that as it was refurbished and still in service in the 1700s. The Ship came perilously near to the nearby ships when the coast eroded severely in the 1700s, but now thankfully it is protected by the King's Road and a much tamed sea. This means that it can remain as a successful historic hotel, owned today by hotels group the Hotel Collection. It is not just a reminder that Charles II was the first monarch to visit the town, but also that this is the last of Brighton's two resort-era assembly rooms (the Castle Inn was demolished on the orders of George IV). In its early day, these were crucial facilities if Brighton was to attract the fashionable classes to its waters and keep them coming back. You can still see the sign pointing to the Old Ship's assembly rooms, aptly enough in Ship Street.

33. Patcham Place

Originally called 'Paceha', Patcham is one of the oldest parts of Greater Brighton, with a church that featured in the Domesday book. The parish of Patcham included land as far away as Coldean until the reorganisation of Brighton in the 1920s. Patcham is where Brighton's 'hidden' river, the Wellesbourne, springs from the wells of the Downs, hence its name. This river surfaced back in the early 2000s and flooded the village. However, it was the manor house, Patcham Place, that was partly responsible for a much earlier flow, but this time of blood.

Most recently a youth hostel, Patcham Place was once the home of Anthony Stapley, one of the Parliamentarians in the Civil War. Stapley not only helped fight against the King, Charles I, (whose son was to escape to safety from Brighton in 1651), but was also one of the signatories on the king's death warrant. So although one Brighton citizen helped kill a royal father in 1649, two years later another citizen saved his son (*see* Old Ship Hotel). Patcham Place is another location to spot Brighton's brilliant black mathematical tiles, which the owner of Patcham Place used to revamp this building, whose origins go back further in time than its current form. Like Preston Manor, a much older-looking building once existed on this site that dated back to 1558, built for William West, 1st Baron de Warr, but it has been covered up with its revamped exterior from 1764. Like Stanmer House, it was also used as a semi-police station, where the parish constable could take criminals to be detained. It is another historically and architecturally valuable building, which is why it is Grade II* listed. Its owner at the time of the railway boom was wise in insisting that the London–Brighton line went through his land, hidden in Patcham Tunnel. So, unlike Preston Manor, this building only has to view the busy A23. Its future looks bright as it is currently undergoing redevelopment into a business and community centre.

34. Portslade Old Police Station

Portslade is an overlooked part of Brighton and Hove, but was once bigger than Hove. The village part is always worth exploring, north of the Old Shoreham Road. Once known as Copperas Gap, the south end was important too as a bustling port which is now grouped together with 'Shoreham Harbour'. The busy south part of Portslade needed its own Police Station, which it got in St Andrew's Road in 1908. Today this old Police Station is unique as it was mothballed in the 1950s and still has many of its original Edwardian features – including three of the original Edwardian police cells intact at the rear. Behind these cells is something even rarer, however, that not many people have ever seen. As Portslade was such a vital port (Shoreham is the nearest coastal port to London), in the 1940s it became a decontamination centre – should the Russians have used chemical or biological weapons, Portslade would have been where soldiers or civilians would have been treated. As the Russians developed nuclear weapons, this bunker at the back of the police station then became a nuclear decontamination centre, one of only six in the UK. Radiation-exposed VIPs or key people would have passed through its shower room if they'd survived a nuclear blast, which still exists today. Thankfully it was never used –except when the local bobbies decided to help the odd drunk cool off – but Portslade still has this remarkable and rare legacy of the Cold War in a residential street today.

Portslade Old Police Station, a mothballed marvel from the Edwardian era but also features a Cold War legacy.
Inset: The Nuclear decontamination centre at the rear of the building. Thankfully it was never used except to give the odd Portslade drunk a shower, but this may well have been vital locally in a post-war conflict involving Britain.

35. Preston Manor

There has been a manor house at Preston, the first village north of Brighton, since at least Norman times and the house itself originally faced west towards Preston Road (what London Road is called in this stretch), but back then the road was known as Brighthelmstone Way. It is not surprising that the 1905 rebuild made the house look north and south, as by that time its westerly view had changed, with the railway cutting through the house's lands (for which the owners were paid £30,000) and the road into Brighton had become increasingly busy. Its first owner, who leased it off the Church, was called Edward Elrington, whose family had married into the Shirley family of Wiston who in turn married into the Western family. In the 1600s it was one of the bigger Sussex manor houses, suggesting Preston was of some importance. All that is left from the 1600s is down in the basement, with most of the house dating from the 1800s and its 1905 rebuild. Preston Manor was also rebuilt in 1738 by Thomas Western, whose family gave their name to Western Road when it was built. Western was lord of the manor and would eventually sell the house to its final family owners, the Stanfords.

The Stanfords, who bought Preston Manor, were hugely influential and also gave their name to parts of Brighton, such as Stanford Avenue and the Stanford Arms (today the Joker pub) at Preston Circus. Preston Circus was on the border of their land so it was apt the pub was here – it was almost a gatehouse to Stanford land. The Stanford estate in 1871 was huge, covering much of Hove and West Brighton, not just Preston Manor and it was not until they sold this land that Brighton and Hove could be properly joined together. Charles Thomas-Stanford, a published author and even mayor of Brighton, adopted his wife's surname of Stanford. The last Stanford, Vere Benett-Stanford, didn't survive long after the First World War and his father, who had hoped to inherit the house, was cut out of the will by his mother, so Preston Manor has since belonged to the people of Brighton. This 'precious national asset', as it was once called by the *Brighton Herald*, can now be enjoyed by everyone and is a place all Brightonians should see and learn about. It is also reputedly one of the most haunted houses in the land.

Preston Manor, viewed from the south-west in the days when the London Road was being used by just the old farm cart. (Courtesy of the Royal Pavilion and Museum, Brighton & Hove)

36. Queens Hotel

Queens Hotel is one of Brighton's most amazing locations. Not only was it once next to the sea but it was also once Markwick's Hotel. Going back even earlier, it was Mahomed's Baths, the site of Sake Dean Mahomed's business empire. At a time when slavery was still legal and racial atrocities were taking place across the world, one of Brighton's leading businessmen was Indian, but this is not to say that he didn't face racism. Starting his career as an Indian doctor treating British soldiers in the Raj, Mahomed made his way to Brighton, married an Irishwoman and, aware of the racist attitudes at the time, started treating the wealthy and royal for free. His 'free samples' of his exciting new health treatments, which included vapour baths and being massaged through a sheet, caught on and he soon boasted mounted crutches all around his treatment rooms of all the patients he had 'cured'. His fame grew and he was appointed as 'Royal Shampooing Surgeon to HRH George IV and William IV', gaining him numerous wealthy clients. His massaging using his fingers is what we do today when applying shampoo, and that it where the phrase originates – 'shampooing' is an Indian term which has changed its meaning over time. Mahomed lived to the age of 102 and is buried in St Nicholas's today. He deserves celebration as a businessman who helped increase the fame and prosperity of Brighton, introduced a term to the English language and is a great argument to those today who question the input of immigrants to our country. Brighton also deserves commending for showing that even in the 1700s it was a tolerant, forward-thinking and accepting city. Queens Hotel may be a later version of Mahomed's baths, replacing the former building in 1870, but it is still a marker of that building that brought a visionary across the sea to us and, as the early picture shows, demonstrates just how close the sea was to the town at this period of time (pictured).

Queens Hotel today, site of Sake Dean Mahomed's Baths. Note how far the sea is today from the hotel.

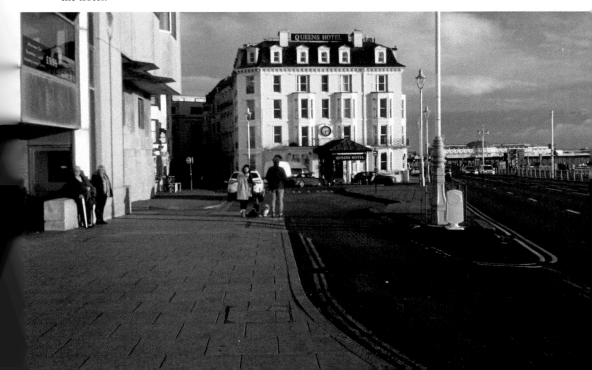

Mahomed's Baths. With the coast road washed away a century earlier, the side street to the north of these baths would experience much movement until the building of King's Road in the 1820s.

37. Railway Works

An unusual and little-noticed building, the graffitied and neglected clocking-in shed in Old Shoreham Road, next to the Montpelier Bridge, was once the entrance for hundreds of men on a daily basis to the massive Railway Works that were one of Brighton's largest employers until the post-war period. If you look closely, you can see the different coloured bricks that provide the clue that numerous hard-working men would have entered here and climbing the stairs to this back entrance to work on building the large number of railway engines that Brighton's main manufacturing industry produced. However, the plant was winding down after the First World War as manufacturing moved to Lancing and Newhaven and despite a temporary respite after 1942 for war work, the plant's days were numbered by the 1950s. This strange little shed today explains why there are so many old photos exist of large numbers of workers walking down past the once-needed parade of shops by Argyle Road, just east of Preston Circus.

Above: The Railway Works Clocking-in Building. This grafittied and neglected building was surprisingly important in Brighton's manufacturing industry.

Below: The extent of the Railway Works that employed hundreds of men from the 1840s to after the Second World War. The workers would have entered and left via the building in New England Road. Note also how Rastrick's Viaduct used to be; today it is completely surrounded by houses.

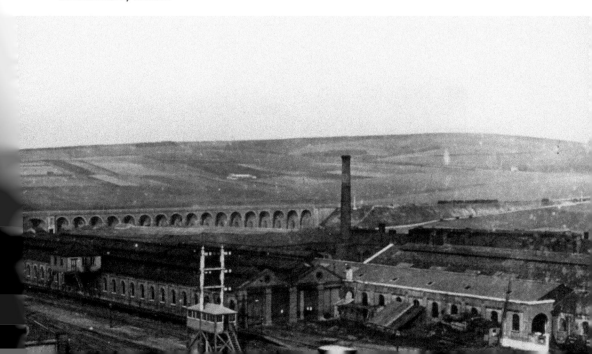

38. Rastrick's Viaduct

Stretching across what was once the land belonging to Preston Manor, Brighton has an amazing Grade II* listed piece of Victorian engineering in its midst that is also a Second World War survivor, the gateway to central Brighton and home to a number of businesses. It is the London Road viaduct, also known as Rastrick's Viaduct after its designer, John Urpeth Rastrick, who also built a similar viaduct over the Ouse Valley. It celebrates its 170th anniversary in 2016, remarkably holding up thousands of tonnes of trains every year, and is made of about 10 million Victorian bricks. It's amazing to think that than when it was first built, its ten arches spanned a valley of fields, not houses, as it does today.

Rastrick also provoked local anger by building a viaduct as local opinion was keen on having an embankment, not a viaduct. It encouraged the city to expand further, and by the 1870s housing estates surrounded the viaduct on both sides. Soon rebuilt after taking a bomb blast in 1943 that caused one of the arches to collapse and left the railway line dangling precariously, it has continued to bring visitors and commuters between Brighton and Lewes. In the novel *Chronophobia* by Thomas Stakeman, the two main characters jump off the viaduct in 1997 and land on a hay cart back in the nineteenth century travelling into the then distant Brighton!

The strangest air raid in the Second World War was the one on the viaduct in 1943 when a Focke-Wulf 190 launched its own version of the Dambusters raid on the Brighton to Lewes railway line at the Viaduct. The bomb hit the bridge, but not before bouncing along Campbell Road, which faced the viaduct, smashing through two houses in Argyle Road and only then hitting the viaduct. There is a story that the cat in the nearest house in Argyle Villas that had been hit was oblivious to the commotion of the raid, apparently not even bothering to wake up. The town defied the Nazis by constructing a temporary line over the smashed railway bridge, which was later repaired in full.

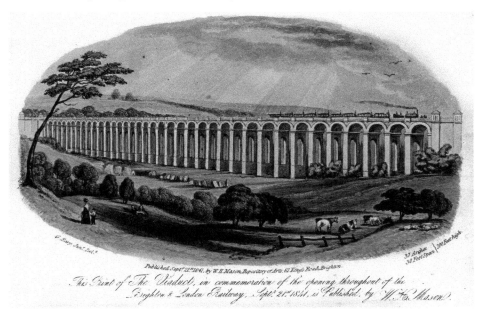

Rastrick's other viaduct over the Ouse at Balcombe.

The route the 'Viaductbusters' bomb took along Campbell Road to the viaduct in 1943.

39. Roedean School

Roedean's reputation has always been the highest – it was once described as the 'Eton of the fair sex'. The girls at the school, many of whom are international students, come to Brighton for their education due to its worldwide reputation. It hasn't always enjoyed its lofty cliff-top location, starting off its days in Lewes Crescent, Kemp Town, before its move to its current home in 1899. Many Brightonians don't know that it has another of Brighton's secret tunnels, so that its girls (properly referred to as Roedeanians) can undertake their beach studies without having to cross the busy A259 coast road. It has even been referred to in a very early episode of *Only Fools and Horses* when a very young Del and Rodney contemplate survival after a nuclear war and decide the school would be their choice for post-apocalyptic girlfriends! The school was commissioned as HMS *Vernon* during the Second World War and had a serious role in developing torpedo warfare. Since the war, the school has developed its good reputation, which has helped to make Roedean a very exclusive place to live in Brighton.

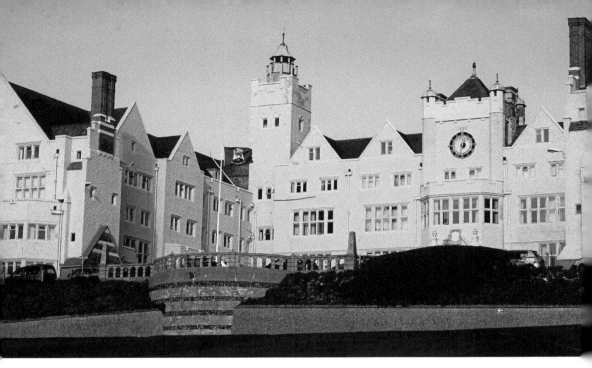

Roedean, Brighton's Hogwarts.

40. Royal Albion Hotel

Not just the spiritual heart of bathing resort Brighton, the Albion (as it was originally; the Royal was added later) is the oldest continually existing large hotel in Brighton which uses the same entrance and will celebrate its 190th birthday in 2016, being built in 1826. The Old Ship is Brighton's oldest hotel but started originally in the 1500s back in Ship Street, not at its current location in King's Road. The Castle Hotel and Tavern was older, but was demolished by George IV, and the York Hotel (YHA today) has not always been a hotel, enduring spells as council offices for a number of years, and was once two houses and the manor house of Brighton before that.

The Royal Albion cannot be omitted from any essential guide to Brighton's buildings, not only because of its architects and its history, but because of also the significance of its site to the development of Brighton and the seaside holiday worldwide. It was the site that Dr Richard Russell, the Lewes doctor who was the most famous of his profession in promoting a seaside visit, chose to base his medical practice and his home. This seashore surgery, which really was close to the sea back then, was located next to the fashionable Steine and also meant that Russell could supervise his patients easily as they bathed at the bottom of Brighthelmstone's small cliffs. It was the spot where the cliffs were at their lowest, except for the spot where the River Wellesbourne drained into the sea, but the 'pool' that is now Pool Valley today could be obnoxiously pungent, so it was avoided. When Russell's dilapidated house was demolished in 1823, the land was meant to be kept as an open space by its new owner, John Colbatch, and Brighton Corporation were to pay him £3,000 to do so. However, they delayed and so Colbatch commissioned Brighton's most prolific architect, the talented Amon Henry Wilds, to build this fantastic example of a Regency-style building. This is today the oldest wing of the hotel, including its main, Steine-facing

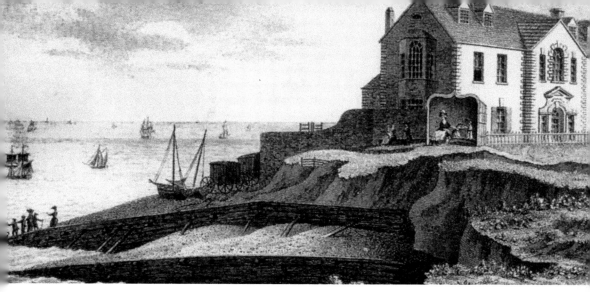

Above: Dr Richard's Russell's House, today the site of the Royal Albion Hotel.

Right: A fanciful image of the Royal Albion after its resurrection by Billy Preston.

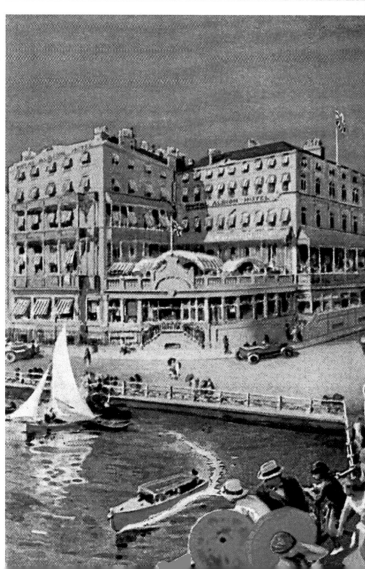

Like most of the large hotels in Brighton, the Royal Albion has suffered from fire. This fire was caused by a chef and thankfully led to no deaths. The oldest wing of the hotel wasn't harmed.

entrance on its north side and it has since enlarged to include a western wing and took over the next door Lion Mansions/Adelphi Hotel in 1963, which William Ewart Gladstone had stayed in. When built, the hotel was still incredibly near the sea, until Prince George funded the 'King's Road' which meant that Brighton once more had an east-west coastal road again (the previous one, South Street, had been lost to storms in the 1700s). This protected the hotel from future storms, and meant it was now north of a wide esplanade, today a dual carriageway. One imaginative portrait of the hotel in the 1920s however seemed to believe the sea (or at least a boating pond!) was still a wave's splash away from the hotel.

It survived the 'seventy-year itch' that afflicts Brighton hotels and when it became unprofitable and unloved it was saved by the hotel impresario Sir Billy Preston, who bought it for £13,000 in 1913. He bought and renovated the hotel, which had actually been closed for thirteen years, and made it into one of the town's most fashionable hotels once more. Following this, the Royal Albion, along with Preston's other hotel the Royal York, became a destination for VIPs, the well-to-do and literary lights of the day, such as Arnold Bennett, who wrote *Clayhanger* there in 1910. Graham Greene was later to appreciate the hotel in the 1950s, saying it provided him tranquillity to write.

The Royal Albion was purchased in 1978 for over £500,000, and again in 1987. It survived a horrific fire in 1998 and with its restoration and refurbishments, it is now one of current owner Britannia Hotel's proudest acquisitions. Today its main entrance faces the Steine as early fashionable Steine buildings all once did. This is not a fashion statement, but more out of necessity as its early twentieth century entrance, which faces the Grand Junction Road, now opens onto a narrow pavement, flanked with a fence to protect pedestrians from the endless traffic. Should this junction ever be pedestrianised, then it would be great if the Royal Albion once more recreated Preston's dramatic entrance facing the sea.

41. The Royal Pavilion

Part of the logo of Brighton and Hove since the city's investiture by Elizabeth II in 2000, the Pavilion today is the most famous part of Brighton and probably one of the world's most famous buildings. It's been described as 'the most magical building in England'. However, it is not the first or only building of its type in Brighton. Nor was it George's first residence here – he initially stayed on the east side of the Steine, but we don't know where. He also stayed at

Above: The Royal Pavilion today. It was never officially a royal palace until William IV took it over.

Below: The earlier plans for redevelopment of Holland's Marine Pavilion, which were never used. The Pavilion just has a Chinese-style interior instead. (Courtesy of Royal Pavilion and Museum, Brighton & Hove)

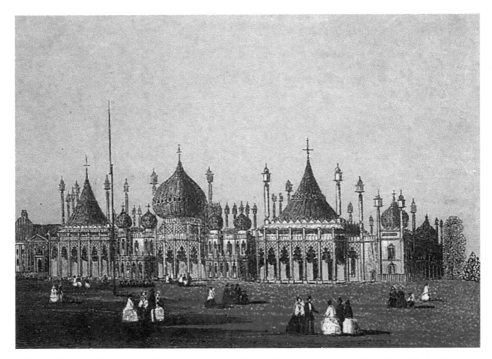

Above: The Pavilion soon after completion of its Indian phase, as designed by Nash. You can see where the Marine Pavilion still existed underneath its oriental overcoat.

Below: The Pavilion in the Edwardian era. Edward would be another monarch with a fondness for Brighton, helping to revive the resort's fortunes. He decided not to make the Palace his official residence though, preferring the exclusive estates of Kemp Town and Adelaide Crescent to stay in.

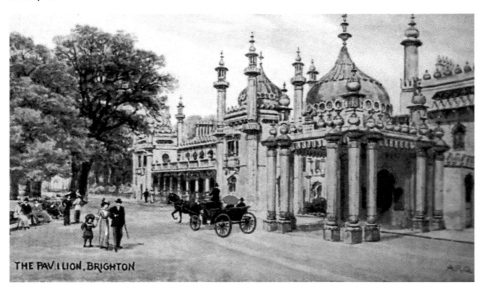

Marlborough House twice. Known in its first incarnation as Brighton Farmhouse, described as a 'respectable' dwelling owned by Thomas Read Kemp, it was rebuilt in four months to become the Marine Pavilion, and then finally the Royal Pavilion. George had first looked at a Chinese-styled exterior, and then when he decided he wanted an Indian-style building his building plans were delayed due to the costs of the Napoleonic Wars. It has also had several other less pleasant nicknames attached to it, perhaps the nastiest being 'Florizel's Folly'. What is amazing about it is that the central part of the building still has the same layout as its earlier incarnation; its Indian-style decorations were mostly 'added on' to the existing earlier building like a mask. The Marine Pavilion was also just the original farmhouse, also known as 'Brighton House', repeated to the north, with a dome in the middle – so the original farmhouse is just about still there, under the cladding of the most eccentric building in Britain. The Royal Pavilion is also a wonderful confusion of styles – Indianesque on the outside with Chinese styles inside. The fashion at the time of its construction was for French design, but as Britain was waging war with the French this move would have been a little insensitive, even for the Prince Regent.

The Pavilion is not the first building in Brighton to have an Indian-themed exterior. The Dome and Corn Exchange were actually designed first in 1805 by Henry Porden, whereas the Pavilion didn't get its Indian styling until the 1820s. George was so pleased with the styling of what is now the Dome that he insisted his Pavilion, built by Henry Holland, was redesigned to make a matching set by Nash. Nash is a huge hero of Brighton as he was never even paid properly for his extravagant work. Like some of the builders and suppliers for the Pavilion, he faced financial ruin due to the prince's slow payments.

The Pavilion was also not the first Indian-styled building in Britain. Sezincote, near Moreton-in-Marsh in Gloucestershire, built in 1805, was partly the design of the man (Thomas Daniell) who produced the oriental pictures that are thought to have inspired George to 'go for an Indian'. The prince (as he was in 1805) was a visitor also to Sezincote, so it was likely to have influenced his thoughts. The Athenaeum was also going to be another oriental-styled building in Oriental Place (hence the name), but it was never built and a successor in what is now Palmeira Square collapsed, and so with the removal of the Palace Pier's theatre and the loss of the West Pier's original oriental pavilion, we are only left with one other Pavilion-looking building today in Brighton – the Western Pavilion, hidden off Western Road. This was built by Amon Henry Wilds. Unlike other styles, Indianesque buildings never really caught on, but this makes the Pavilion more unique.

Not only did the Pavilion change its look several times, it changed its environment and the layout of Brighton too. George wasn't happy with East Street on the palace's east side bringing the masses so close to his holiday home, so he had the road stopped, the palace gated on its north and south-eastern sides and the gardens changed to reflect this. Traffic was diverted around the western side of the palace or to the east further, to head north across the Promenade Gardens. The new road that was built across these was called, unimaginatively, 'New Road', which gives the city its premiere pedestrianised street. Today it is graced with the Theatre Royal and numerous restaurants. The purchase of the Promenade Gardens also meant that George could build his riding school and stables – the Dome, museum and Corn Exchange today. He also had the Castle Inn and Hotel demolished. The Chapel Royal also moved due to George's intervention.

The Pavilion has some interesting features which also add to its uniqueness. It has an internal frame of metal and metal inside its elaborate stonework; this was very advanced for the age but has been a problem with water seeping in and rusting it from the inside. The

Pavilion also has a staircase that is not all it seems. It is made of iron and painted to look like bamboo, as when George IV first had the staircase made iron had never been used for interior decoration before. The whole staircase was originally iron but George decided it was too cold to touch, and had the top part of the hand rail replaced with mahogany wood and painted again to resemble bamboo; this meant that his visitors would not get cold hands when holding the rail. This is all part of the exotic fantasy that George was trying to create. Perhaps this inspired another staircase that went to great lengths to ensure the guests wouldn't get cold hands – the Metropole, built seventy years later, had the country's first heated staircase, which was powered by steam and was seen as incredibly luxurious at the time.

The Pavilion also has another key figure we should know about after Porden, Nash and the Prince. Lewis Sleight is not a Brighton name most people know, but this officer at Brighton Corporation saved the Pavilion. In 1837, Queen Victoria decided to sell the building as she felt the people of the town intruded on her privacy. In addition, other structures were now blocking the sea view the Prince Regent had enjoyed from his bedroom. She took all the furniture to Buckingham Palace and the land looked set to be sold for development. While waiting for the town corporation (the council) to vote on whether it should be purchased by the town at a cost of £53,000, Lewis Sleight went secretly to London and purchased it for the town anyway, as the Forestry Commission, who owned the land had decided to sell it. The debate over purchase by the council rattled on for many years and was finally saved after a vote that only won with a majority of thirty-seven. And it only cost a tenth of what the prince had paid to build it. Incredibly cheap in view of the estimate of the money spent on all the different pavilions came to £1 million – this would be billions today. Not only was money spent on the pavilions but on the visitors; one menu from a banquet in 1817 listed 116 dishes. However, recently it more than paid its way as the town's first conference centre and as a major tourist attraction brings in 4 million visitors from all around the world, despite the setbacks it has faced. In 1975 damage was caused when an arsonist set fire to its music room. It also was affected in the 1987 storms when the minaret crashed through the ceiling of the same music room.

Its proudest moment must be that the Pavilion was one of a number of buildings used for treating hospitalised Indian soldiers during the First World War in Brighton. The government's reasons were twofold: first that it could be adapted into a state of the art hospital and second that it could be used as British propaganda. Although the building no longer belonged to the royal family, India was part of the British Empire and the king. The government did not let it be known that the Pavilion was no longer a functioning royal palace but allowed it to be believed that it was still a royal residence in the hope that the soldiers from India would feel very special and appreciated. They would believe that they were being cared for in a home of the king. It was said that many woke up from comas or unconsciousness believing they were either at home or had passed beyond this life. This caring idea was for many years attributed to the king, George V, but it was not his decision to make; by 1914 it had been Brighton Corporation property for nearly sixty-five years – it was the councillors' idea. It was a bit misguided, however, as the interior was more Chinese in style than Indian – not that you'd complain, however, if you were allowed to recover in an ex-palace.

Many people know the Royal Pavilion (along with the Dome and other venues) was the hospital for wounded Indian soldiers in the First World War, but not many know of its other role during the conflict. From December 1914 to January 1916 it was a hospital for Indian soldiers, but its second phase was from April 1916 to May 1920, when it became a hospital

for British limbless soldiers. This was because the Indian suffering were suffering greatly on the Western Front, the weather being in stark contrast to their warm homeland, and during the course of the war the War Office decided that they would be better suited fighting in Mesopotamia (modern-day Iraq). This also meant that they would be closer to India if they needed to return home to convalesce. So the Pavilion not only looked after the valiant Indian combatants but also those from Britain who had lost arms or legs. Born at the time of the wars with France, and utilised in the Great War, the Pavilion has a rich and varied history and is a world-renowned and magical palace of a type that has never been seen before or since.

42. Royal York Buildings/Hotel/The Radisson Blu/YMCA

Today the YMCA, this amazing building was originally the Manor House of Brighton in an earlier form, and was joined with two other houses. Collectively, they were known as 'Steine Place', which had been Brighton's manor house. That house had been constructed of red brick, thought to be in the middle of the 1700s and was owned by Richard Scrase, the lord of the manor at that time. It's most famous era was when redeveloped to become the Royal York Hotel. It was named in honour of the Duke of York (Prince Frederick), who was the Prince Regent's brother. It was also much loved by William IV and Queen Adelaide but, like the Royal Albion Hotel, fell into a poor state at the start of the twentieth century, to be rescued by Sir Harry Preston who sold it for £32,500 to Brighton Corporation. They used it for offices until the twenty-first century and renamed it the 'Royal York Buildings'. Married couples will look fondly at the building as they started their wedded lives there, as the offices also housed the town's registry offices. It will be 200 years old in 2019 and so is unique as its main building is the only truly Regency-era building of its type, and one of a surprisingly small number in Brighton. The Regency Era is technically only 1811 to 1820,

The YMCA today. Fun to stay in apparently, but no longer the exclusive hotel it once was when it was the Royal York Hotel.

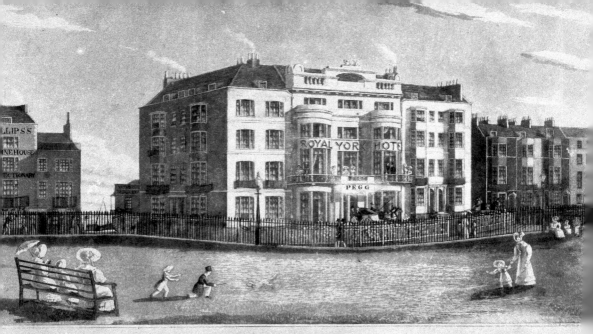

ROYAL YORK HOTEL,
OLD STEINE,
BRIGHTON.

The Royal York Hotel when managed by Pegg, who ordered its enlargement. (Courtesy of Royal Pavilion and Museum, Brighton & Hove)

when Prince George was regent, yet buildings from the 1840s were still built in this style, such as the Seven Dials area and even some Brighton buildings built in the 1860s still claim today to be 'Regency'.

It is another literary hotspot of Brighton, having had prime minister and author Benjamin Disraeli as a resident. Thackeray also graced it with his presence and in 1861 *David Copperfield* was read to audiences there by Charles Dickens. It hit the heights in terms of early aeronautical fame when the aviator Wilbur Wright stayed in the earlier years of the twentieth century. The Royal York had an impact on other areas of the town too, as its name was so prestigious that the owner of the hotel in its early days renamed his other developments after his hotel, which is why we have York Place and other streets with that name near St Peter's church. Another manager, Harry Pegg, took over in 1827 and enlarged the building so that it gained its east and west extensions. After the Castle Inn was demolished in the 1820s, the York and the Ship became the locations of the town's most exclusive concerts, recitals and balls. After a recent dalliance as the Radisson Blu Hotel, it now houses the town's first YMCA.

43. St Bartholomew's Church

Praised by architectural critics in the modern Pevsner guide, Brighton has a church that was supposedly built to the dimensions of Noah's Ark. St Bartholomew's in Ann Street is also amazing for a number of reasons, many of which are due to the man who commissioned it, Father Wagner, who along with his father built many churches in Brighton. When it

St Bartholomew's. 'Wagner's Folly' caused a number of problems but remains a fantastic and unusual piece of architecture.

was built in 1874, the locals complained that it affected the smoke from their coalfires, blowing it back into their houses, so Father Wagner paid them to stop complaining. One of the biggest churches in the country, it is even taller than Westminster Abbey when you include its cross. It was meant to be even longer, however, but Wagner decided it needed to be taller instead (it was going to be another two bays longer northwards), which is why it is still unfinished today. In making it taller than it was meant to be, Wagner went against planning permission and opted to pay the fine rather than make his church any shorter. Today, it is still possible to climb the great church, built by architect Edmund Scott, and the novel *Chronophobia*, set in 1990s Brighton, does indeed get its characters doing just this for the final climactic fight scene on the church's roof. It is possible to climb to the cross from inside the church, and the church has a walkway halfway up its interior, with spectacular views. Moving to the present day, television series *Cuffs* has used the church too, as a setting for a story of a church volunteer stealing from the church, and its streets alongside were used for its 'inner city' scenes, but it is still a magnificent piece of Victorian architecture. It was even rumoured to appear in a chopped-down version as the backdrop for the lawyers' offices view from their windows in 1980s US television court drama *LA Law*. It originally had a small chapel facing it, built in 1830 and revamped in 1857, but this was demolished in the twentieth century. To the unfinished rear, at the northern end, you can still see the original St Bartholomew's school.

44. St Nicholas' Church

From Brighton's biggest church, we move onto its oldest. Not many people realise that Church Street is so called as it leads up to St Nicholas' church, which dates from the 1300s and is arguably also Brighton's oldest building. There are arguments over whether the Knab or Poole Valley are older, but it is likely any buildings in these two locations were destroyed by the French. St Nick's also had a vital function for several centuries as a navigational beacon for sailors at sea approaching the town. It may have helped back then, but it confuses us today with two of Brighton's mysteries – why was the town's church away from the town, up on a hill, especially when St. Nicolas is linked to the sea, and therefore to the fishing town below in the valley? Its lofty location might suggest it had a role in the plague of the 1340s in keeping plague graves away from the town or there might even have been an older Brighton community around St Nick's. However, no evidence has ever been found to suggest either. The second mystery is why the Domesday book of 1086 records Brighton as having a church but there is no evidence that St Nick's is that church. So where was Brighton's earliest church? Even more mysteriously, St Nick's has a decorated font which dates from the 1160s, which is even older than its exterior. Could this font, the oldest physical part of Brighton, be from the older church?

Mysteries aside, the church was extended in 1853 and its original building faced an extreme makeover on the orders of Arthur Wagner. He removed too much of the early church but its graveyard makes up for this. A history book in its own right, the graveyard tells the story of many of the town's key people, including Sake Dean Mahomed, Phoebe

St. Nicholas' Church. Central Brighton's oldest building and site of several mysteries.

Hessell, Martha Gunn, Nicholas Tattersall and Amon Wilds Senior. Brighton's senior building, like the town, has been much altered from its earliest days, but still tells a fascinating story.

45. St Peter's Church

The nearest thing Brighton has to a cathedral was designed by Charles Barry, architect of the Houses of Parliament. It was originally called the 'Chapel of Ease' as it wasn't a proper church at first, but designed to ease the overcrowding in St Nicholas'. It was built between 1824 and 1828 after a competition between architects, which Barry won, beating local architects Wilds and Busby. When built it interrupted views from buildings north of the church down to the sea. It is not only one of the finest examples of religious architecture, but one of the first churches that can be described as Gothic in the early nineteenth century. It is also on a river bank, not that you'd know though, as the River Wellesbourne flows underneath the ground in Valley Gardens past St Peter's. There are currently plans afoot to bring the river to the surface by the church though, which would be wonderful. It is also a bizarrely two-tone church, as it was so successful it needed to be extended in 1906, but the new part used different stone, meaning that one end is white and the other yellow! It is now officially Brighton's parish church, taking over from St Nicholas', and is so important it even announced the royal visit of the Queen and Duke of Edinburgh in 1979 with a full performance of ringing of its bells.

St Peter's Church before its later extension which made it a two-tone church. (Courtesy of Royal Pavilion and Museum, Brighton & Hove)

46. The Starlit Room/Chartwell Suite

Although not technically its own building, as a room on top of an existing building, but as it was built seventy years after the original and changed the look of the building, I believe it deserves its own mention. It was also the first rooftop restaurant anywhere in the country, which makes it worth including. Its architecture is also so different from the building it sits upon that it makes it unique.

AVP Industries' purchase of the Metropole in the 1950s saved it from plans to develop all floors of the hotel, except for the lowest two, into flats by its original owner, Gordon Hotels. Despite being an example of Waterhouse's astounding architecture, the hotel had been losing £10,000 a year for a decade by 1959 and critics foretold the death of Brighton as a resort. The rumours that the great Victorian building would even be demolished were widespread, to much anguish from Brightonians. Luckily, the Chief Executive of AVP, Harold Poster believed otherwise – that Brighton could be a world-leading destination and that the hotel could be profitable once more – but it would need a complete refurbishment and new features that would make the hotel attractive to the rich and famous of the Space Age, not the Victorian Age. As well as new flats at the back of the hotel, bathrooms were added in every room, a new Winter Garden and redecorated throughout. However, the (literal) crowning glory of the hotel was to be a new 150-foot-high rooftop restaurant, the first in the country. At the height of the Cold War, with the Space Race running and the superpowers reaching out to the stars, it was apt that the restaurant also looked upwards and took its name from the heavens: the Starlit Lounge. Stars and celestial navigation provided the decor as well as the idea that of the most romantic restaurant in Brighton should be lit by the stars. Stars were even etched onto the numerous glass panels and windows. The timbers supporting Waterhouse's famous rooftop and spire were found to be structurally unsafe

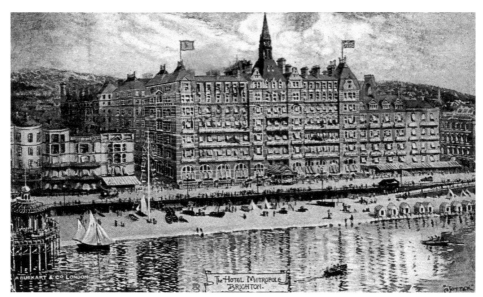

The Metropole in the 1910s, half a century before the Starlit was perched where the main spire is here.

Above: The view from the Starlit at its peak in the 1960s.

Below: The Starlit today, now a function room of the Metropole. It is called the Chartwell, presumably after Harold Poster's Chartwell Court tower block nearby, or celebrating the Winston Churchill link with the hotel, and is awaiting a forthcoming refurbishment.

and so the top two floors were reconstructed and strengthened to support the new dining location, where diners would have a view from on three sides from Hastings to Worthing when it opened in October 1961. The rear of the room would be home to a Starlit Bar, kitchens and a Starlit Foyer, which featured an exciting space age metal sculpture. The view of the roofline was lost, but now for the first time, a new view existed – that of Brighton from 150 feet up. Brighton's first attempt at an i360 had been built.

Despite gloomy predictions that the hotel and restaurant would never be profitable again, Poster was proved right and the Starlit meant the royal, rich, glamorous and famous patronised the Metropole once more. The cocktail bar was a success and live music played every evening except Sundays. The Starlit's French cuisine won top awards and the price of a meal matched its opulent location, with £60 a ticket being the price to dine on New Year's Eve in 1965.

The Starlit was forced to close in August 1975, not due to lack of success but, like many hotels, the national 50 per cent pay rise meant it could not pay staff wages. It reopened briefly in the 1980s where it was described as the 'most opulent restaurant in Brighton', but with the West Pier having closed to the public and rapidly decaying, the view wasn't what it once was. Today, the room is the Chartwell Suite, a multipurpose room for hire that still hosts dinners, as well as business conferences and other private functions. With a forthcoming refurbishment pending, and the West Pier's spectral frame providing an iconic image, Brighton's 'first i270' will soon provide a luxury venue once again.

47. Sussex Heights

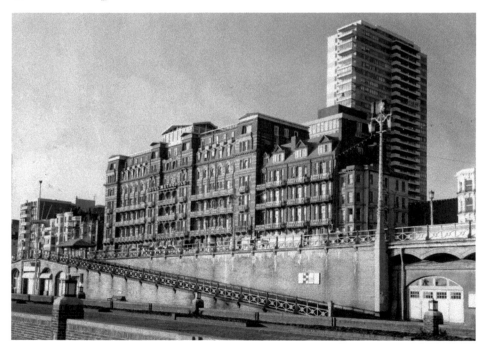

Sussex Heights in relation to the revamped Metropole after Poster's changes in the mid-sixties, which included the Starlit Rooms, seen here perched on top of Waterhouse's Victorian building.

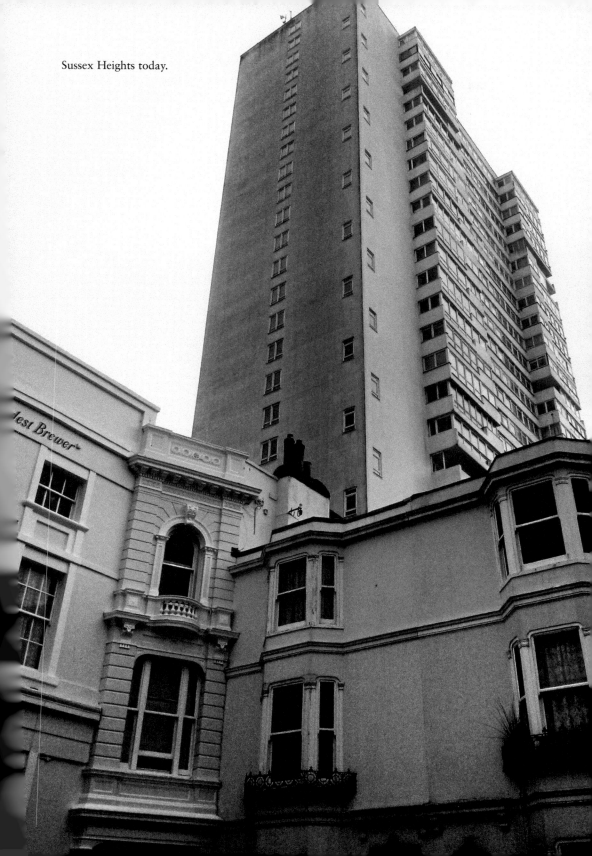

Sussex Heights today.

It is incredible to think that Sussex's tallest residential building, Sussex Heights, has now towered over the seafront, the Metropole and Regency Square for over half a century. Tower blocks of its kind seem of another era, and yet it seems unfeasible that early blocks of flats could be that old.

The new owner of the Metropole from 1959, Harold Poster drew up plans for the 300-foot-tall tower soon after purchasing the hotel. Instead of converting the majority of the hotel to flats, he built the exhibition hall complex, added two floors of flats onto the rear of the hotel (Metropole Court) and maximised profit from his purpose with a luxury block of flats. Sussex Heights drew criticism from the way it dominated the skyline and dwarfed historic Regency Square underneath, but its design certainly has more aesthetic value than the later nearby Chartwell Court (also by R. Seifert) and the unloved tower blocks elsewhere in Brighton. Sussex Heights may not be everyone's favourite building but its residents certainly love it, and that includes the feathery kind. The tower is home to peregrine falcons, who presumably like the viewpoint for hunting from Sussex's tallest residential building.

48. Theatre Royal and the Colonnade Bar

Brighton's main theatre was first in a barn in Castle Square, but when it was needed for the harvest, performances were stopped. It was then based in North Street and after that in Duke Street, opening in 1774. It moved to its current location in New Road in 1807, soon after the road was created on land that had once been pleasure gardens, and cost £12,000. It's first two shows were *Hamlet* and *The Weather Cock*. It was rebuilt in 1866 and 1894, copying the trend for red brick and terracotta that the Metropole had made popular. Like many theatres, it has a ghost. It is said to be haunted by the ghost of Sarah Bernhardt, a leading French nineteenth-century actress, who must have enjoyed her several performances here in the 1870s and 1880s as she presumably chose to return here rather than her other venues she appeared at. The layout of the theatre has changed over the years, which might explain why Miss Bernhardt has been seen to be able to knock on a solid wall in a corridor backstage before gliding through it. Where she enters was indeed once the door to the ladies' dressing room until the layout of the theatre was reorganised in the twentieth century.

A wholly different type of spirits can also be found next door in the theatre's wonderful Colonnade Bar, which takes its name from the covered walkway with pillars that used to extend all the way along the road against the New Road buildings to North Street. Visiting the Colonnade is another chance to travel back to the Victorian era, with its dark painted ceiling, rich decorations and heavily flocked wallpaper. Signed photos of stars who have trod the boards next door grace the walls, smiling down at you from the height of their fame, and there is no better cosy bar on a winter's evening.

49. Jury's Inn Brighton Waterfront

Brighton's massive 1980s hotel has had numerous name changes since its opening as the Ramada Renaissance, back in 1987. Back then, before the mooting of the i360 and as the

Right: The Waterfront Hotel, now rebranded as a Jury's Inn. This 1980s 'Modern Metropole' is slowly growing in Brighton's affections and doesn't stand out as much as it used to.

Below: An earlier vision for the Waterfront's site in the days when the Town Hall's days seemed numbered. The Ramada Renaissance/Town Hall extension replaced this plan.

West Pier fell into ruin, the western end of the town was increasingly being neglected. This meant that the central part of the town around the Palace Pier made sense as the location for a 1980s interpretation of the Metropole and an opulent new 5-star hotel. The building has Victorian proportions but used modern concrete facing and angular green glass to give the impression of a glass visor at its seafront entrance. It has not been architecturally acclaimed since its construction, but its location and 'Winter Garden' atrium make it an interesting construction. The Jury's Inn Brighton Waterfront seems to be the winner for most name changes as previously it has been the Thistle, Thistle Brighton, Brighton Thistle, Hospitality Inn and then before that, the Ramada Renaissance.

More interesting, however, is its inception and what has happened inside it in its brief history. It was originally part-owned by Brighton Council, who sold their shares in it in 1989, the year when it was voted third-best new hotel in the world by businessmen. It is also unusual in having what used to be called a 'Winter Garden' planted inside its building back in the 1980s, with trees from Florida growing indoors and low-level plants from Belgium and Holland. Its edible greenery must also have been good in the 1980s as it was given the highest rating in East Sussex by famous food critic Egon Ronay back in 1989, scoring 82 per cent in Ronay's hotel guide. This matched the five-star rating the hotel had, at a time when the number of 'stars' a hotel had was all-important. It hosted the Labour Party and TUC for several years during the conference season too. Half of its 204 rooms were refurbished in 1998 and 1999 at a cost of £1.09 million.

Like all Brighton hotels, its bar and restaurants have been the setting for many a romantic date. Back in September 1992, however, it hosted auditions for the Saturday night television show *Blind Date*, hosted by the late Cilla Black. Passers-by would have been mistaken for thinking one of the political parties was holding their annual conference, as security was so tight. The local media were even banned from entering and some had to be frogmarched from the premises, leading *Argus* journalist Ian Lauchlan to enter under the guise of a potential contestant.

Other celebrities at the Waterfront Hotel in the past included Roy Castle, at the launch event for the hotel back in 1987. The hotel even had a pianist, John Grace, who would travel every day, up to seven days a week, to play at the hotel from the Isle of Wight! Status Quo guitarist Rick Parfitt stayed at the hotel after a concert and was allowed to do all his own cooking in the hotel's kitchens. *Neighbours* star and singer Jason Donovan spent most of his time there in the gym at the height of his fame, obviously toning his body for Kylie! Ex-Royal Marine HRH Prince Edward lived up to his well-known hard man image by being pleased with the plastic ducks in his bathroom. In October 1989, tennis star Steffi Graf stayed in the Presidential Suite when playing at the Brighton Centre and was only charged £99, rather than the usual £550 for the suite, as then-manager Nick Menzies said, 'If someone is at the top of their profession, they deserve special treatment.'

The most interesting conversation the staff must have ever had was with an American visitor back in the 1980s who was trying to flush the toilet using his remote control. Obviously the Americans must have been a lot more advanced than we were in the eighties!

It has also certainly lived up to its name of the Hospitality Inn, as it was called back in 1989, when it kindly stepped in to host a Christmas party for eighty children of ambulance drivers, after fundraising by readers of the *Brighton & Hove Leader*. This was after the party had to be cancelled due to lack of funds. The hotel, it was when the Thistle hotel, even tried to help save Brighton & Hove Albion in its darkest days of financial crisis in the

early 1990s by hosting a beauty contest to raise funds. The Albion has since boomed, and with its location, new name and ownership as part of the Jury's Inn group, the Waterfront should be the same also.

50. West Pier

Brighton should take pride in the fact that we had the only Grade I listed pier in the country and that it survived as long as it did. The pier's creator, Eugenius Birch certainly lived up to his name, not only giving us the Sea Life Centre (or Aquarium as it was first known), but a fantastic pier in 1866 that was amazing. Like the Millennium Bridge in London, when first built it wobbled and so Birch reinforced it, making it bigger, wider and stronger – all using the brute force of his workmen to screw the metal pillars into the seabed. The wobble disappeared. The improved pier was so strong that the reinforced Victorian sea end is the last bit still left remaining, despite all that 150 years of weather, war, neglect and arson can throw at it. To give you a comparison of how good 1860s building was compared with that of ninety years later, when the pier was rebuilt in the 1950s following its being cut in half to stop the Nazis ever using it as a landing jetty, it was this new bit that fell apart first, not the reinforced Victorian ironwork.

The West Pier wasn't only cut in half once either, just in the war. The great storm of 1896 that made the Chain Pier collapse blew the debris into the thirty-year old pier then, chopping it in half and costing a massive £6,000 worth of damage then. Of course, the final storms and arson attacks of the last fifty years chopped it up again, leaving it in its current

The West Pier in its Edwardian splendour.

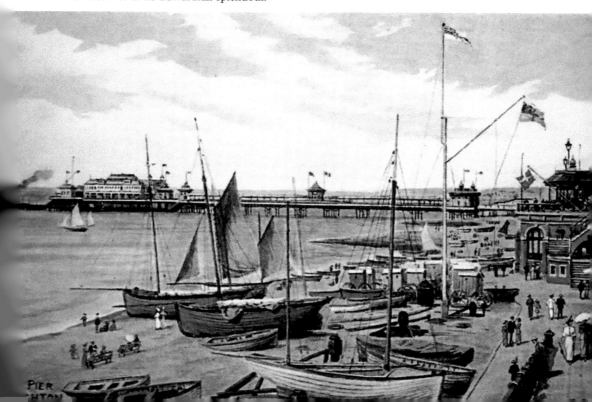

PIER
HTON

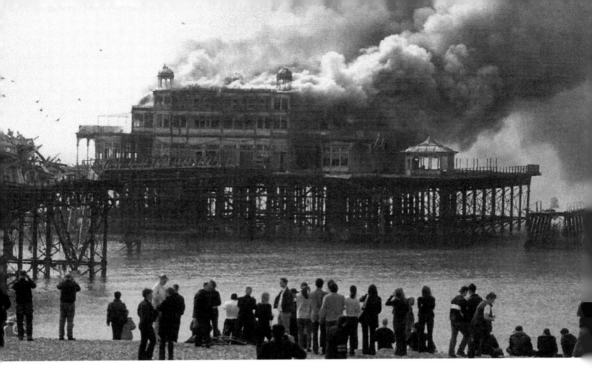

The West Pier undergoing one of its two sinister fires. The gutting of the pier scuppered the West Pier Trust's plans to secure lottery funding for its restoration.

disjointed state. The West Pier refuses to die completely however, and hopefully its sea-battered skeleton can still be the basis of a future restoration and a new West Pier. A lot is resting on the future success of the i360, and one of the benefits of Brighton's most modern engineering masterpieces may be the rebuilding of one of its earliest.

Acknowledgements

The author and publisher would like to thank the following people and organisations for permission to use copyright material in the book. Every attempt has been made to seek permission for copyright material used in this book. However, if we have inadvertently used copyright material without permission or acknowledgement we apologise and will make the necessary correction at the first opportunity.

Thanks to Mike Gilson, Editor at the *Argus* and Kirstie and Sascha at the Hilton Brighton Metropole for the generous use of their archives. My gratitude also to Douglas d'Enno and Antony Edmonds, two brilliant and dedicated historians of Sussex who have supported me greatly and allowed kind access of their many talents and sources, as well as giving great advice. Also, thanks to Paula and the PR staff at the British Airways i360 for their images and numerous fascinating facts about this intriguing new addition to the Brighton skyline. Peter James and his PA Linda Buckley have also been generous again as well as supportive in allowing me to use Peter's images and put questions to him, and my dear friend Amanda Jane Scales, who kindly allowed me to pick her very knowledgeable brains. Iain, the GM at the Mercure Brighton Seafront, has been generous with his time and support, and thanks to Emma from my tours and Chris Wellwood. Jackie Marsh-Hobbs and Max at the Sea Life Centre, my thanks for your help and huge gratitude to Kevin Bacon, who kindly granted permission for use of many of the Royal Pavilion Museum, Brighton and Hove's images. Most of all, thanks to my parents for editing anything from the 1940s onwards and my wife Laura and boys, Seth and Eddie, who have been dragged around Brighton since their days in a buggy.

Brighton & Hove Walking Tours

For a guided walking tour or talk based on this book, please call All-Inclusive History on 07504 863867 or email info@allinclusivehistory.org for prices and for group bookings. See www.allinclusivehistory.org for further details of this and similar tours and talks.